What People Are Saying About
The Energy Within Us

"If there were a hall of fame for the energy industry, these five remarkable women would be unanimous first-ballot inductees. They are true pioneers who—through their passion for helping others and their terrific achievements in the business, energy, and environmental fields—have set the bar high for all leaders, regardless of gender or ethnicity. Their inspiring stories serve as a roadmap to help other women find success in whatever career or endeavor they choose."

Thomas R. Kuhn
President, Edison Electric Institute

"I highly recommend that everyone—especially those who are part of the energy and utilities industry—read this fascinating book of the unique challenges and successes of true trailblazers in our field. Providing critical services to millions of people every day is difficult enough; to do so while also breaking down barriers of gender and race for decades is an almost impossible mission. Yet these women *did it*. Read their inspiring and incredible stories of vision, passion, and commitment to make our communities and workplaces better, stronger, and more inclusive."

Susan Story
CEO, American Water

"These women open up their lives to you in a powerful and penetrating way. Each shares what inspired them, what propelled them, and upon whose shoulders they stand. You will be taken on journeys anchored in faith and true grit. You are in for surprises, laughter, and tears. Ultimately, you will find yourself in each of them. They care deeply for their communities, their country, and God's green earth."

Vicky A. Bailey
Former Assistant Secretary Department of Energy

"*The Energy Within Us* is a fascinating and inspiring tale of how five African American women rose to the highest levels of one of the most critical industries in the US. All of them came of age when the energy industry had an overwhelmingly white- and male-dominated culture. Yet each of them refused to believe that she couldn't play a role in shaping the future of their companies and bettering the lives of their employees and customers. Reading these stories can't help but make you optimistic about the future of our country."

Anthony Earley
Retired CEO, DTE Energy
Retired CEO, PG&E Corporation

"*The Energy Within Us* is a testament to the power of perseverance, determination, faith, hope, and love. This book should motivate every woman, especially women of color, to discover the power to overcome any obstacle by believing in oneself and finding strength from within. The stories of these five fearless, trailblazing women inspire us all to dream, pursue, believe, and achieve."

Colette Honorable
Partner, Reed Smith
Former Commissioner, Federal Energy
Regulatory Commission (FERC)
Former Chair, National Association of
Regulatory Utility Commissioners (NARUC)

"Awesome! That is my view of this inspiring book. I know these extraordinary women who share personal insights about the incredible challenges they each overcame to climb the corporate ladder. Strong values, internal fortitude, a sense of urgency, and desire to make a positive difference in people's lives drives them. Their stories are passionate, compelling, and inspirational. This book is a must-read for (black) women aspiring to corporate leadership, and it presents them with a keen focus on achievement."

David K. Owens
Retired Executive Vice President, Edison Electric Institute
Board Director, Xcel Energy, Puerto Rico Electric Power Authority

"*The Energy Within Us: An Illuminating Perspective from Five Trailblazers* is an inspiring viewpoint that must be shared. Get to know five leading African American women who continue to pave the way in the development of our country's energy and environmental policy. You will be richer through their acquaintance."

G.K. Butterfield
US House of Representatives (North Carolina)

"Hilda Pinnix-Ragland does me the honor of calling me her mentor, but the truth is quite the opposite. For two decades I watched her successfully traverse boundaries that don't constrain people like me, and she did so with exceptional grace, humility, and patience. Hilda's story is one of family, education, effort, and goodwill for all—great lessons from a great mentor."

William "Bill" Johnson
CEO, PG&E
Former CEO, TVA
Former CEO, Duke Energy
Former CEO, Progress Energy

"Energy is a life-changing force, and throughout cultures around the world, women determine the many ways society uses energy. The more women know about energy—particularly clean energy—and its many uses, the better chance we have of preserving civilization for the next generations. The five women featured in this book are all high-powered leaders in the energy industry, who through persistence, resilience, preparation, and a strong commitment to education, have become experts in their fields. As the Under Secretary of Energy in President Obama's administration, I founded the Clean Energy Education and Empowerment (C3E) organization for women as way to build on the legacy of great women leaders in energy like those in this book, as well as Secretary of Energy Hazel O'Leary. Young women aspiring to careers in the energy industry will surely find inspiration from the life stories of these five women who never forgot where they came from, how they got their start, and the role of education in their journeys. That they now give back through programs such as the C3E and Minorities in Energy further demonstrates their commitment to encouraging future generations of women to become leaders in this field."

Kristina M. Johnson, PhD
Chancellor, The State University of New York

"Storytelling is a powerful and memorable narrative form, and these are stories that deserve to be told and shared. The leadership journeys on these pages provide us with living and moving role models. Yes, these stories are especially for women and written specifically by black women. But, more importantly, they provide us with universal truths about courage, grace, and the human spirit."

Sarah Fisher Gardial
Dean, The University of Iowa Tippie College of Business

"Beyond the potential, kinetic, and nuclear energy these women display, *The Energy Within Us* sparks the emotions of the human spirit. These five inspiring stories tell of African American women from very different backgrounds, navigating their careers through the challenges and opportunities; each of these women rises to success in the corporate energy world. They share the importance of the support they received from mentors, the courage it took to take risks, their perseverance in facing challenging situations, and their determination to encourage those who follow in their footsteps. The stories of these trailblazing role models are an inspiring *must read!*"

James G. Kaiser
Retired Senior Vice President, Corning, Inc.
Fortune 500 Board Member
ELC Founding Member

"It's one thing when you know someone by their work; it's another when you know them by their heart. I have been lucky to call these women my mentors and friends for more than 25 years. *The Energy Within Us* tells their stories. Stories that lay out the path to personal and professional success. This book gives us a glimpse of their journeys as servant leaders. It will inspire you to do more no matter where you are in your own career. I encourage you to travel their roads as you read this book and experience what they have done for so many of us in the energy industry. The lessons learned are invaluable and I will carry them with me throughout my life. I know that everyone who reads this book will be inspired to do the same."

Paula R. Glover
President & CEO, American Association of Blacks in Energy

"From its very beginnings, North Carolina A&T has always been a place where women of color learn, grow, and achieve. Today, we're not only among the nation's leaders in graduation of African American women in STEM disciplines at the undergraduate and graduate levels, we are proud that accomplished women lead our programs in such STEM fields as Engineering, Nanoscience, Health Sciences, Cybersecurity, Computer Science, Civil, Architectural, and Environmental Engineering and Biology, as well as our academic programs overall. Blazing a trail begins with the education to prepare one for that journey, and we're proud to be an institution where so many bold, high-achieving women in the energy industry and related sectors have found their start, including Hilda Pinnix-Ragland. Her leadership within and understanding of that field shines in *The Energy Within Us*, and I believe it will inspire future generations to enter an industry that is critically important to the future of our nation and the world."

Harold L. Martin Sr.
Chancellor, North Carolina A&T State University

"*The Energy Within Us* is not just a book that chronicles the professional experiences of five very talented black professional women, but a narrative of courageous leadership that forever disrupted the old boys' culture in the energy sector. Truly, a *must read*."

Ronald C. Parker
Former President & CEO, The Executive Leadership Council
SVP, Human Resources PepsiCo

The Energy Within Us

An Illuminating Perspective
from Five Trailblazers

ATKINS & GREENSPAN PUBLISHING

For information about this title or to order other books and/or electronic media, contact the publisher:

Two Sisters Writing and Publishing DBA
Atkins & Greenspan Publishing
18530 Mack Avenue, Suite 166
Grosse Pointe Farms, MI 48236
www.atkinsgreenspan.com

ISBN 978-1-945875-60-1 (Hardcover)
ISBN 978-1-945875-61-8 (Paperback)
ISBN 978-1-945875-62-5 (eBook)

Printed in the United States of America
Cover and Interior design: Van-Garde Imagery, Inc.
All photographs used with permission.

Dedication

"If you want to go quickly, walk alone. If you want to go far, go together"

—African Proverb

This book is dedicated to the memory of everyone who has made us who we are: our families, friends, churches, and communities who made us believe we could be whatever we wanted if we were willing to work hard; our coworkers and bosses who demonstrated the importance of teamwork; mentors and sponsors who shared the unwritten rules of the workplace and spoke on our behalf when we weren't in the room; and to those people who told us we would never succeed… and gave us the determination to prove them wrong.

From its beginning in July 1977, when Clark Watson convened a meeting of 12 men and one woman, the American Association of Blacks in Energy (AABE) has not only influenced energy policy at federal, state, and local levels, but it has provided a unique showcase for African American talent. Then in 1986, 17 African American male and two female corporate executives formed The Executive Leadership Council to identify, support, and increase the number of African American executives in Fortune 500 companies. Both organizations have contributed immeasurably to the growth in the number of African American women in corporate America and in

the energy industry in particular. The importance of a supportive network, especially for those of us who are isolated within our companies, cannot be understated, as others have endured tragic fates from which we continue to grow.

Most of all, this book is dedicated to all of the bright, beautiful, fearless, and FIERCE black and brown girls who are just beginning to dream of their own future. We hope our stories about our varied pathways to a career in a STEM-dominated industry will move you, challenge you, and interest you in pursuing a career in the energy industry. Safe, clean, reliable, and affordable energy is the bedrock of economic vitality, not only here in the US, but also for the 1.5 billion people (mostly in communities of color) throughout the world who still don't have access to the energy resources we take for granted. We look forward to reading the stories of your careers and your lives; they're out there waiting to be told!

Acknowledgments

Joyce Hayes Giles

I thank my parents, Myrtle and Isaac Hayes, who set me on the right path of life, who instilled in me the courage to act, the character to always do the right thing, to believe I could do anything in spite of adversity, and to live life with a purpose.

I'm grateful to the village, my church, and my teachers, who inspired and pushed me to believe that I could achieve and become someone making a valuable contribution to our world.

I thank my daughters, who—by their mere existence—taught me unconditional love. They often tell me how they learned to be ladies because of the lady I am. What a mother's dream: to be that first female role model.

I appreciate Hilda Pinnix-Ragland for encouraging us to write our stories. I thank Carolyn Green, Telisa Toliver, and Rose McKinney-James for agreeing to partner and write this book.

I thank my company, DTE Energy, for providing the opportunity to lead at the highest level of management; to serve the community by providing resources; and to make a difference in the lives of many.

I thank the employees of DTE for allowing me to lead and jointly serve all sectors of the company.

I thank my phenomenal circle of girlfriends who are always there, providing love and support.

Lastly, thanks to Two Sisters Writing and Publishing: Elizabeth Atkins (for guidance and scribing), and Catherine Greenspan for her help publishing our book together.

Carolyn Green

I am eternally grateful to the village that raised me—starting with my parents, but also my church family and the black community in our town—who always supported and affirmed me, even if they didn't always understand my path. My father may not have been well-educated by society's standards, but I've tried to model his quiet thoughtfulness and thirst for knowledge. I learned to be fearless from my mother, who was ferocious in advocating for her children and always said exactly what she thought. My uncle's blindness taught me that handicaps, whether real or perceived, are limiting only if you allow them to be. My brother's effortless talent at so many things forced his little sister to be disciplined and determined if she were to have any hope of keeping up with him. As an adult I have been blessed with so many mentors, role models, and friends that naming them all is impossible, but my co-authors are special friends and collaborators on so many levels. And I hope our stories will inspire little black and brown girls—like my granddaughters Valerie, Gaby, and Bella—to reach even higher than we've been able to achieve. Above all, my best friend, husband, and partner in life has told me countless times that I should write down my experiences. Michael, this one is for you!

Telisa Toliver

I have many to thank...

While we are quite different, I credit the core of who I am to my mother first. Secondly, I thank my father, who like my mother, taught me how to think critically and love unconditionally... to a point.

My grandparents, who reminded me that I "come from good stock," indicating a legacy to uphold. The "first group" of my aunts and uncles, who were the accomplished and who set the stage. The "second group" of aunts and uncles, who did it their way and from whom I learned just as much.

My brothers, who put up with me, supported me and my extravagances, and have always taken care of me.

My stepmother, with a special bond. To my blood, Dayne and Joe. To Ed. To my crew of ride-or-die girlfriends. To the incredible women who contributed to this book, whom I admire so much and who embraced me with open arms... and wine!

Thank you.

Rose McKinney-James

I must always begin with "the end in mind." I lovingly acknowledge and dedicate this effort to Fred and the boys, Erick and Avery. I happily honor the memory of my maternal grandparents, Burniece and Robert Avery, and Rev. Elizabeth Crews, my Mom Shirley/ Teri Thornton and the father I never knew. I share this journey and legacy with my brothers, Kenneth and Kelly. I shall be forever indebted to Olivet College and Professor John Stevens for pushing me beyond my limits and providing a safe space to explore my future. My heartfelt thanks to Arrington Dixon, Sharon Pratt Dixon Kelly, Ruby Duncan, Russ Dorn, Ashley Hall, William H. "Bob" Bailey, Governor Richard H. Bryan, Governor Bob Miller, Senator Harry Reid and Team Reid, Billy V., John and Mike Ensign, Kirk Kerkorian, Terri Lanni, and Heather and Jim Murren for deeply enriching my life through trust and providing a series of remarkable opportunities to evolve. Love and hugs to my BFF and besties for providing the friendship, support, and humor that fuel me daily. I will always be profoundly grateful to Congresswoman Shirley Chisholm and President Barack Obama for their faith in an otherwise unknown hidden figure for their iconic leadership, strength, and poise in advancing the importance of community and public service.

Hilda Pinnix-Ragland

A child's foundation is directly linked with three primary factors: education, environment, and economic well-being.

Along with strong values and integrity, my great grandparents, grandparents, parents, uncles, and aunts—supported by exceptional educators—taught me the beauty of: loving your neighbor as yourself; listening for understanding; being rather than seeming; giving rather than receiving; and cultivating lifelong happiness skills. Mentors, mentees, and sponsors are equally important.

Simply said, I am overwhelmingly grateful and appreciative of all known and unknown support.

I applaud my AABE national, regional, and state organizations for providing intellectually stimulating and relevant energy education, its members with exceptional support, and the distinguished North Carolina Chapter. Joyce, Carolyn, Rose, and Telisa, thanks for joining me on this journey as we share points of wisdom, lessons, and courage. Your insight will illuminate the road as future generations successfully enter and advance within the energy industry.

Family is for life: thanks to my birth sisters—Venice, Condoza, and LaRosa. Special thanks to my selected sisters—Allyson and Cheryl, who understand and love me regardless!

Finally, Dad, Mom, Uncle Charlie, Clyde, and Sharon—this book is dedicated to you.

Special thanks to my remarkably patient and supportive husband, Al, who has allowed me to fly for 36 incredible years.

And more gratitude goes to our successful daughter, Katherine Elizabeth, who gave us a wonderful granddaughter, Kenley Madison.

Foreword

As I read each chapter of *The Energy Within Us*, three words kept coming to mind: *Inspirational*, *Instructional*, and *Intentional*.

These five women, Carolyn Green, Telisa Toliver, Joyce Hayes Giles, Rose McKinney-James, and Hilda Pinnix-Ragland, titans in the energy industry, have generously shared their stories of embarking on a career journey that would take them to the pinnacles of success in an industry with a dearth of women and a dearth of people of color.

As I read each story, I found it *inspirational* that there were no road maps, examples, or even obvious mentors to give them prescriptive advice on how to even exist in the energy industry, let alone how to navigate an industry that has a reputation for being populated and driven by "the good ol' boys." It was inspirational to read how each woman talked about how her family values of faith, relationships, commitment to excellence, and education were the drivers for her courage to enter an industry where there were no obvious forefathers or foremothers, yet they went bolstered by these values and a village of people who were rooting for them. I found it inspirational that none of these women were willing to belabor or be distracted by societal mores or expectations, yet were driven to reach and attain beyond those expectations.

The book was *instructional* in its detailed account of how they took on assignments, trusted bosses, and stepped up for roles that were new and unproven. It was instructional how 30 years ago they were asking for stretch assignments and frankly questioning decisions that were made for them and not by them. I found it both instructional and inspiring how each of them found the patience and the fortitude to wait when they were told, and in the case of Joyce Hayes Giles told directly, "your day will come" and to in effect, grin and bear it, when she was passed over for a well-deserved promotion. Each of us today as readers could learn something from the fact that they not only waited, but how each in her own unique way, chose to use that time while they waited. It was instructional how each of them found the organization, the American Association of Blacks in Energy (AABE), and leveraged the organization to not only make friends, but to build allies, cultivate mentor relationships, and even to find sponsors. They used AABE as their training to learn how to network and how to effectively use organizations to augment and, in some cases, catapult their careers.

Lastly, I was struck by each woman's *intentionality* around being successful. Carolyn's pursuit of becoming conversant in several industries and building and keeping relationships with people who don't look like her; or Joyce's constant self-affirmation of "I am better than that" every time she encountered someone looking down on her or her potential; or Telisa's commitment to affirmatively taking risks experientially and geographically; or Hilda's commitment to lifting as she climbed, learning to play golf, and getting involved in the political arena; or Rose's commitment to public service and leveraging her relationships. All five women took a level of intentionality that is a lesson for all of us today. Success does not just

happen; you must be intentional about it. These women have been intentional about not only their careers, but their commitment to the families that spawned them, to the families that they built, to the people who helped them to build and advance their careers, to those coming alongside and behind them. They have intentionally sought success, but not to the exclusion of spiritual, financial, mental, or physical health. They have offered readers several roadmaps of how to do and have it all, even in industries which are not at first blush accommodating of women or people of color.

I invite you, readers, to join me in taking the journey with Carolyn, Rose, Hilda, Telisa, and Joyce. They are offering real truths and advice on how to navigate any career, amidst any challenges, as they give you their personal stories. What they have given us in The Energy Within Us is indeed, inspirational, instructional, and intentional.

<div align="right">

Carla A. Harris

Vice Chairman, Global Wealth Management

and Senior Client Advisor

</div>

Introduction

You've heard of the glass ceiling.

It's the barrier holding women back from breaking through to the highest echelons of corporate America. A few women are promoted to those power seats, but the realm of leadership in America's top companies remains mostly male—and mostly white.

If striving for success in that reality weren't daunting enough, some women face an additional barrier: the black ceiling.

That's the barricade blocking African Americans from ascending into the top levels of corporate leadership.

Black women who aspire to become senior executives or CEOs face the double obstacle of the glass and the black ceilings, especially in certain industries where the statistics for female and black representation are discouraging.

Think about how difficult and disheartening it might seem as a black woman aspiring to excel and transcend to a corporate leadership position through the glass ceiling and the black ceiling in the historically white male energy industry.

We are five African American female executives who have achieved all of the above.

And by sharing our stories in this book, our objective is to offer our lives and our careers as inspirational blueprints for other women and people of color who aspire to leadership positions in the corporate arena.

We have blazed new trails in the energy industry by shattering ceilings. However, much work remains. The low representation of women and people of color at the helm of corporate leadership requires a strong commitment to persevering past the many obstacles that can delay and derail a career.

That is why we convened on the pages of this book to show that, *Yes, it can be done!* We show it through: our own personal belief systems; networking with other women and people of color in our industry; receiving guidance from mentors; committing long hours to our jobs; relocating when opportunity knocked; pursuing our education and training to propel us on an upward trajectory in our field; and celebrating the successes as they come.

Very importantly, we have demonstrated a commitment throughout our careers—and now into retirement for some of us—to reaching back to mentor others so they can follow the paths that we have blazed into uncharted territory for women and people of color in corporate America.

We hope that by reading *The Energy Within Us: An Illuminating Perspective from Five Trailblazers,* you will be inspired and informed about how to succeed in business and in life.

Sincerely,
Joyce Hayes Giles
Carolyn Green
Telisa Toliver
Rose McKinney-James
Hilda Pinnix-Ragland

Contents

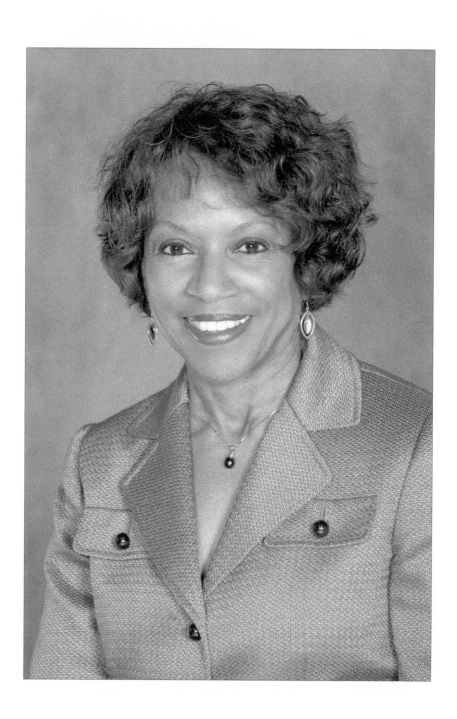

The Energy Within:
A Career Marathon

by Joyce Hayes Giles

"The first step toward success is taken when you refuse to be a captive of the environment in which you first find yourself."

— Mark Caine

When I was a child, the pinnacle of success for someone in our black community was to become a doctor, a lawyer, or a teacher. The reality for most black women at the time in segregated Mississippi, however, was to become a homemaker or a domestic worker.

The words *corporate executive*—much less *black female corporate executive*—were as foreign to us during the 1950s as terms like *microwave oven* and *cellular phone*. These terms were not part of our lexicon because they had yet to exist.

As a result, I had no inkling whatsoever that I would someday become assistant to the chairman and senior vice president of Public Affairs for DTE Energy. This was a publicly traded company on the New York Stock Exchange, another concept that I never heard while growing up.

However, I later ascended into a once-inconceivable, elite corporate arena because my parents and my "village" of relatives, teachers, and our church family convinced me that I could achieve anything. They did this by building a strong foundation for my personal and professional success.

Even though my mother scolded me in a protective way for using the "whites only" drinking fountain when I, as an innocent little girl who knew nothing of the racist laws of the land, attempted to quench my thirst during an outing in our town of Jackson, Mississippi.

Even though I saw our family friend and church member Medgar Evers on the television news, bleeding to death in his driveway after being gunned down for his work to advance civil rights.

Even though my father was killed a year later, and the person responsible was not prosecuted.

Even though my mother struggled to raise five children alone, and endured the tragedy of her youngest son's death with no recourse from those responsible.

Even though we attended segregated schools with time-battered desks and tattered books.

Even though the greater society viewed us as less intelligent, less worthy, and less capable of leading companies and communities to become their best.

So, how was my quintessential, against-the-odds story made possible?

The "village" that comprises my family, teachers, and church members fortified an indomitable, personal infrastructure of character, faith, education, and ambition within me. This foundation was far stronger than the negative influence of the greater society.

"You are going to go to college," our parents repeatedly told me, my two sisters, and my two brothers.

However, they could not pay for us to attend college; they assumed we would earn scholarships. That's why they constantly pushed us to do better, do more, and excel. These messages were reinforced by our teachers and people in our close-knit community at New Hope Missionary Baptist Church.

The African proverb that, "It takes a village to raise a child," may seem cliché and overused today. But for me, that was the secret to my success as a child, as a teenager, and as a college student in a hateful world that expected failure and/or dependency rather than success and leadership from someone of my gender and race.

While the village laid the foundation for my future, the electricity that activated my internal fortitude to launch into a successful life and career was my deep belief that I was determined to prove society wrong.

"I'm better than that," I told myself every time I encountered an example of the mainstream looking down on me and my potential. I neutralized and erased that negativity by constantly repeating my mantra in my mind:

I'm better than that.

I'm better than that.

I'm better than that.

The roots of this belief were nurtured in our home, especially by my mother, Myrtle Hayes. She was earning her bachelor's degree in education when she met my father, Isaac Hayes.

"You have permission to marry my daughter," my grandfather told him, "but she must finish college."

Education was valued in the black community and was viewed

as the only way out of poverty. Slaves had been prohibited from reading. Education was important in our family for generations and my grandfather wanted it for his kids and demanded it of my mother, Myrtle.

My mother was the first of her siblings to attend college. My father obtained his high school equivalent degree through class-work done in the Army.

She did complete college, and began working on her master's degree in education when I and my four siblings were growing up. We were stair-step children, and my oldest sister was tasked with taking care of us younger kids while our mother was attending classes.

During that time, our father did not want our mother working outside the home. He wanted her home taking care of us.

He was a good provider, a true entrepreneur in spirit, which translated during those times as being a hustler. He worked for Swift & Company, a meat processing plant, and he owned a store called Hayes Busy Corner. After school, my siblings and I would walk to the store and the employees would give us candy and send us along our way. Our father did not want us to linger around the store.

Mississippi was a dry state, meaning it was illegal to make, buy, or sell alcohol. I suspect my father was a bootlegger, selling moon-shine to do what he viewed as necessary to provide for his family when few opportunities were available for people of color.

We were poor by most standards, although not as poor as others in our community. We always had a home. My dad had served in the US Army, which provided a mortgage program that enabled him to purchase our modest, single-family house where I shared a room with my two sisters.

Our basic needs were met. We always had food and lunch money; many of my classmates did not, and I often shared my food with them. We had the bare basics for clothing. I had one pair of Oxford shoes that I wore until my feet grew too large to fit them. Only then would I receive a new pair.

While my father was a provider, he was physically abusive to my mother. Sometimes I would beg her to divorce him.

"God will take care of it," she always responded.

Looking back, I know she had few choices. She was dependent to ensure that her five kids were cared for.

Church: Our Sanctuary

We attended church every Sunday. In fact, our mother was such a pillar of our religious community that our father used to say she thought the church doors couldn't open without her and her five little kids. Our father attended his family's church in the country.

My siblings and I attended Sunday school, as well as vacation Bible school during summer vacation.

Church was a place for worship as well as socializing. It truly was a village atmosphere because our neighbors, teachers, relatives, and friends all convened on Sundays to talk, hug, and share a sanctuary of faith and love that provided respite from the racist world outside the church walls.

Here we were encouraged, celebrated, and strengthened.

"Joyce is a very bright, smart child," my high school biology teacher, Mr. Rigsby, used to tell my mother after the service.

Just as our educators were church members, our church members were educators. I was learning first-hand lessons on the Civil Rights Movement from Medgar Evers, who attended our church

with his wife, Myrlie. I was very impressed with him and his family.

On Sundays, he would report to the congregation about his work as secretary of the NAACP, sharing all the injustices and discrimination that were occurring, and how he was working with the organization to improve conditions for black people.

His reports inspired me to reflect on the time when my mother yanked me away from a drinking fountain marked "whites only" when I was very young and had no comprehension of our state's separate and unequal laws of segregation. I also remembered when a little white girl called me the n-word and it was clear to me, even as a small child, that she was simply parroting what she'd heard adults say, because she did not know what that hateful word meant.

The conversations that Medgar Evers led at our church also inspired me to ponder the stories that I had heard my aunts, uncles, and grandparents share about the racism and hatred that were rampant and deadly during that era. It was so unfair. I prayed that someday, somehow, things would change, and that perhaps I could play a role in that progress.

I never felt more loved or more safe than with my church family and my own family, which enjoyed many meals and visits together.

Every summer, my brothers and sisters and I spent a week or two visiting our grandparents, who lived in the country on a large farm with cotton fields and farm animals, including chickens and pigs. Time with them was a fun, far-away adventure from some of the realities back in Jackson.

Tragedy Strikes—Twice

When I was 14, Medgar Evers was shot in the driveway of his home on June 12, 1963. His children, who were younger than me, were inside the house with his wife. I was horrified to watch a TV news report showing the civil rights activist lying on the ground, bleeding to death. This was a terrible reminder of the perilous world we lived in, and how pushing for change could be deadly.

The following year, tragedy struck even closer to home. Typical of the era, my father had a mistress and a second family. Unfortunately, when he tried to break up with her, she shot him. My mother took all five of us kids to the hospital, including my sister, who was home from Spelman College for the Christmas holiday.

"Hopefully," my mother said, "he'll be able to come home and we'll take care of him."

He never left the hospital. During that time, he was another black man whose life was taken, and the woman who shot him never served a day in prison.

My dad died on December 22, 1964. My mom did not want to ruin our Christmas, so the funeral was held after the holiday on December 27.

Witnessing her perseverance as a widow instilled in me tremendous strength and belief in creating a way out of no way. Likewise, witnessing her difficult marriage and its tragic ending, I vowed to never stay in a hurtful or broken marriage.

My father's death left our mother in a desperate situation: she urgently needed to work to support five children. She also lacked any experience with finances; she had never written a check in her life, as our father had handled the money matters.

Here is where the village also saved our family.

Education Is Our Salvation

A school principal who belonged to our church offered my mother a job to teach at one of the elementary schools in Jackson. That way, she utilized her two degrees in education to both support our family and provide a fulfilling career. She was my first *real* female role model.

In school, we knew that our teachers cared about us and wanted us to excel, despite our hand-me-down books.

"It doesn't matter about the condition of the book," they told us. "It's what's in the book, and how you apply it, that matters."

They were super encouraging, making us feel that we could achieve anything we dreamed. That helped us know that we were not limited by mainstream society's perception that we could do nothing or that we came from nothing.

"You can be whatever you want to be," they told us inside the walls of our all-black, segregated school.

Mr. Rigsby, my biology teacher, was the most supportive and complimentary of my intelligence, ability, and potential. Positive reinforcement inspired my ambition to do even better. I was extremely eager to attend college and get a job to advance myself and the world around me.

College

As a teenager, I knew I would attend college, but was unsure about what career to pursue. If anybody had told me that I would become a corporate executive of a Fortune 500 company, I would have drawn a blank, because I didn't know what that was.

When you grow up lacking role models in corporate America, you have no appreciation for the possibilities in those industries. As

a result, the people around me at the time defined success in three ways: doctor, lawyer, or teacher.

I did not want to be a teacher. My mother worked extremely hard for little pay, as did my father's only sibling, who was also a teacher.

Nor did I want to remain in my older sister's shadow by following her on a scholarship to Spelman College, where her studies would ultimately lead her to become a pediatrician. She was the valedictorian of her graduating class at our high school; I was the salutatorian in my graduating class, ranking second in academic achievement in the class of 1966.

As for my younger siblings, my sister, Gwendolyn, whom we call "Gwen," who was two years behind me, also attended college, ultimately earning a master's degree in public health.

The youngest siblings were our two brothers, Isaac and Sterling. Sterling joined the military and lived in Germany for a while. When he returned to Mississippi, he died at age 25 of a sudden heart attack. Though the circumstances were potentially grounds for a lawsuit, my mother feared she would have little chance for justice in a courtroom to prove negligence in the death of her young black son. Here again, our mother persevered through pain with faith and grace, demonstrating to her children how to remain strong in trying times.

Such were the realities for African Americans during the mid- to late-1960s when my sisters and I attended college. Thankfully, our high school guidance counselors assisted us in completing applications that enabled us to attend and finance our higher educations. I was accepted to the premiere Spelman College, and several other schools, which all offered scholarships.

I chose Knoxville College, an HBCU (Historically Black College and University) in Tennessee, where I would attend on a full scholarship. Moving 500 miles away from home and gaining my independence was a thrilling experience. Other than family road trips to New Orleans, I had never been outside the state of Mississippi.

I was eager to earn my education because I viewed it as a step toward getting a job and creating a better life than the struggles I had watched my parents endure. An undergraduate degree, I believed, would be the key to opening doors, although I did not know where those doors would lead.

On campus, I shared a dormitory room, and ultimately had a room of my own. I loved meeting people who shared my ambition and desire to make a positive impact on our world. Our desire to work our way up and out of the poverty and oppressive circumstances of our childhoods inspired us to work very hard to excel academically. My peers and I shared a perspective that race was neither an obstacle nor an excuse not to perform or excel.

My fascination with how people think and behave inspired my major in psychology with a sociology minor. I loved the idea of working with people so much that I considered becoming a psychologist, though I had no role model in that area. I soon realized that this pursuit would require me to attend graduate school and, if I wanted to become a psychiatrist, medical school.

I earned enough credits to graduate one semester early, but I did not return to campus for spring commencement due to unrest on college campuses, including HBCUs. On May 4, 1970, National Guard soldiers shot at Vietnam War protesters at Kent State University in Ohio, killing four students and wounding nine others. As a result, I canceled my plans to return to Knoxville to receive my diploma, which was later mailed to me.

In the interim, I postponed my pursuit of a graduate degree because I was eager to join the workforce. In addition, I married my college sweetheart during my senior year. This was the first of what would be two marriages. My first husband was older than me and had already graduated and moved to Hartford, Connecticut. I moved there and began my first job at Connecticut General Life Insurance Company. Because I had a psychology degree, I was placed in the field of Human Resources, which was called Personnel at the time. As an analyst, I really enjoyed focusing on the employees, their earnings, and their jobs.

This was my first job, and I was determined to do well, thanks to the work ethic that my parents had instilled by repeating, "Always do your best."

As a result, I worked hard, accepted many assignments outside of my job description, and was promoted to positions of increasing levels of responsibility that included management. This was my first leadership role, and I loved it! I was also very effective. I realized that I was born to lead, born to be a leader, and born to manage, counsel, and direct people.

At the same time, I was experiencing a bit of culture shock. This was my first time in the North, and my first experience interacting with people who were different than me. In segregated Mississippi and at Knoxville College, I was surrounded by African Americans.

Now, my colleagues—as well as people whom I managed—were Caucasian and other ethnicities. In the South, we knew we weren't liked, and were always made to feel that we were not as intelligent, as deserving, or as capable as whites. In the North, I sensed this belief was there, but it was not overt.

In the workplace, I did not feel discriminated against. Nor did I feel that people didn't want to work for me because I was African American. I did, however, always feel conscious of being female.

At the time, when corporations were trying to meet quotas for hiring more women and minorities, they began to favor black women because we fulfilled two goals in one hire. Thus, I was double-counted as a female and as an African American. I became part of the "double whammy syndrome" because unfortunately, this trend was occurring at the expense of black male candidates.

I became very conscious and uncomfortable with this, and I would often address it in leadership meetings. It was important that black male professionals be fairly considered for job openings and promotions.

Throughout my career, I relished the opportunity to form relationships with people who did not look like me. I knew that's how it was supposed to be. In fact, I formed a deep friendship with a very liberal Caucasian woman named Trudy, but lost track of her when I moved to Michigan.

We were relocated to Detroit, where I was recruited to work for the Chrysler Corporation, and continued to excel careerwise. My first marriage ended after relocating to Detroit. I refused to remain in an abusive marriage and chose divorce.

I fully immersed myself into my career and was recruited from the auto industry for another job at the American Automobile Association (AAA). I remained in Human Resources, but in a higher level of management. My enjoyment of management and demonstration of leadership skills were rewarded with ever-increasing opportunities.

I decided to obtain further skills. While still working full time, I returned to school to earn an MBA from the University of Detroit.

U of D offered an appealing program in which I could earn both an MBA and a law degree. However, I chose to pursue the MBA at that time. I was extremely grateful that AAA financed my MBA.

This was my first opportunity to compete in an educational environment that was multiracial and multicultural. My excellent academic performance reinforced my belief that I was no less intelligent or capable than anyone else.

Investing the time and energy into earning my MBA paid great dividends. Within a couple of months, I was recruited by MichCon, the energy company supplying natural gas to residents across Michigan.

After I interviewed for the position of Manager, Wage & Salary Administration, MichCon offered me the job. When I turned in my letter of resignation to my boss at AAA, I was shocked at his reaction:

"What would it take for you to stay?" he asked.

He did not want me to leave the company!

I told him what MichCon was offering. Much to my delight, AAA matched my MichCon offer. I felt so valued.

And I was shocked! This girl from Mississippi was in a bidding war between two major companies in Detroit! AAA's counteroffer convinced me to tell MichCon that I was not going to accept their offer, and that I would stay at AAA.

I thought it was settled, until my home phone rang on a Saturday morning. The caller introduced himself as the Vice President of Human Resources at MichCon, Steve Ewing.

"I want you to know that we really want you to come and work for us," he said. "We like your background, and we want you to know that you would have a great future at our company.

I was so impressed that he called me on his day off. I was also shocked that this senior officer of an energy company was outlining the promise of future career opportunities if I made the right decision.

After a weekend of weighing the pros and cons, and not wanting to go back and forth, I accepted the position at MichCon. My bosses at AAA expressed dismay, adding that they believed I would eventually regret my decision. They said, "Why would you go to work for a 'sleepy utility company... You're going to be so bored!'"

Those were famous last words! Fast forward... I never regretted my decision. And I was never bored!

I joined the energy business at the peak of the industry's challenges, and was catapulted into the business as it evolved. The energy crisis was wreaking havoc around the world, especially in the US, where customers were experiencing the impact of increased costs to heat their homes and even use their stoves. Customer complaints escalated, the essence of which included the oft-repeated dilemma: "I'm losing my home because my energy bills are higher than my house note or mortgage."

Homes were not energy efficient, so people were spending lots of money to heat their drafty homes. Clearly, we needed a solution. And fast!

So I represented MichCon (now DTE) along with other utilities across the state, and we created an energy assistance program, now a 501(c)3 organization known as THAW—The Heat and Warmth Fund. THAW remains relevant today with its mission to keep Michigan families healthy, safe, and warm. Since its inception, THAW has distributed more than $172 million in assistance to more than 232,000 Michigan households.

All the while at MichCon, I was following the upward trajectory that Steve Ewing had outlined that Saturday morning so many years earlier. The energy industry was really taking off, especially with the exciting merger between MichCon and DTE Energy, which supplied electricity to millions of people across Southeast Michigan. At the time of the merger, MichCon had 2,500 employees, while DTE had just over 10,000 employees and was listed in the S&P Fortune 250.

Every step of the way, I was shown that true success is achieved where preparation meets opportunity. This lesson was reinforced by many opportunities afforded by the mentorship of Steve Ewing, who had been promoted from VP to the company's President.

Specifically, I was working in Human Resources at MichCon, and Steve recognized that I was at a crossroads that required that I choose my future path: either remain in the Human Resources arena, which had limited growth potential, or gain exposure and experience in different areas of company management so that I would be able to lead at an executive level.

This inspired serious contemplation. At the time, I had 10 years of experience in HR. Was I ready to give that up? I had gone to MichCon to work in Human Resources, thinking that I would stay for two or three years and move on.

Steve told me that while HR is great, if I wanted to ascend at MichCon, I would need to learn the business of the company in other departments. He also said that I really needed to become a student of the energy industry, so that I would understand trends and future projects. This deeper industry knowledge would bolster my ability to steer the company towards growth and success.

At that point, I had to make a decision. Would MichCon

become a career company for me? And if so, I needed to move out of HR and into other areas of the company. Or would I remain an HR professional and ultimately move to other companies?

I decided to broaden my scope of experience and expertise by learning the energy business and staying at MichCon.

This was another decision that I have never regretted. This decision resulted in opportunities in customer service, materials management, supply chain, quality, and a lot of areas that had operations. As a result, I became valuable to MichCon and DTE.

Concurrent with this, and my ever-burning need for education and growth, I decided that I did want to get that law degree.

"You will not be successful in law school," a consultant told me during an assessment at MichCon. At the time, I was still considering law school. Thanks to my parents telling me that—despite negative messaging toward women and people of color about our potential for success—I could be and do anything, I did not allow this person's discouragement to deter me.

I applied to Wayne State University's School of Law and was accepted into the evening program so that I could continue working full-time and not affect my successful career. The class was so large, we were identified only by numbers and not names. That was a real shock to me. But my ability to compete intellectually in a diverse educational experience—and even excel above some of my peers, thanks to my very hard work—again proved that intelligence and ability are not predetermined by race or gender.

On the first night of law school, I met a man, our eyes locked, and it was like a mutual love for each other was evident, and we fell in love. We took every class together, got engaged, and married on April 9, 1983, during our last year in law school. Shortly thereafter,

I got pregnant and gave birth the following year to our daughter Kristen—during spring break! I did not miss a beat with school.

Questions About Marriage & Motherhood That Men Don't Hear

Marriage and motherhood provoked comments that revealed rather patriarchal perceptions about women in the workplace.

"I assume you're not going to finish law school because you have a husband now," said a senior leader at my company.

"Now that you're having a child," others said when I became pregnant, "I'm assuming you're going to drop out of law school." Nobody asked this question of my husband. Men don't have to face those kinds of things.

After our daughter was born, we were both determined to successfully complete law school, so we developed a system. Some evenings, he attended class, and I stayed home. Other times, I attended class, and he stayed with our baby. Whoever attended class would tape-record the lecture, so that the other benefited from hearing the professor's lessons firsthand.

I studied a lot. After maternity leave, I returned to work, finished law school, then studied for the bar exam. I had no social life. That is the trade-off when focusing on your career. My husband and I both graduated from law school on time, and were delighted to have our daughter with us at the ceremony.

We also passed the bar exam the first time, which was especially remarkable because we were working full time and had a baby. I was proud that neither marriage nor motherhood compromised my career, and I certainly did not forfeit my pursuit of education and advancement in the workplace because I got married and had our daughter.

Once I made a decision and committed to it, I worked hard to achieve the desired goal. However, my decision-making abilities became a focal point after I earned my Juris Doctor.

The chairman of MichCon at the time said that I had the ability to make good decisions and that I was very decisive. But individuals, he believed, come out of law school unable to make decisions because they train you to see both sides of a coin. You argue based on the rules and the clients that you have. The decision can go either way. There is no black and white in the law.

"In management," the chairman told me, "I pay you to make decisions. Assume the risk, and make a decision."

I was very skilled at doing just that, even in law school. In my criminal law class, I would jump to a conclusion very quickly about whether a person was guilty or not. I was astute enough to not verbalize this to my professors. The bottom line is: I never lost the ability to make decisions. This skill has been extremely valuable as I was promoted at MichCon, confirming that I was born to be a leader of people.

I was also determined to have a family and a career. My generation was the first to "have it all" and prove that it could be done successfully. Sadly, I had a miscarriage at one point. But five years after Kristen was born, our second daughter, Erica, was born on my 40th birthday!

"You're one of the best birthday gifts I could have ever had," I tell her to this day.

Ultimately, my husband and I grew apart and divorced. I tried not to see this as a failure to having it all—family and career. My ex-husband and I work together when it relates to our daughters. Because we remain friends, we set an example for many, because we

can be in the same room and be very cordial and friendly to each other, and we are very mature about the outcome. We always put the mutual love of our daughters first.

"Your Day Will Come"

Unfortunately, throughout my career, as I was promoted from supervisor to manager to director, then vice president, then senior vice president, I witnessed other people, who had less education and fewer accomplishments, receive promotions to various levels of leadership ahead of me. At times this was very discouraging.

"Continue to do a good job," Steve Ewing told me. "Your hard work will be noticed. Your day will come."

At the time, he had become the president of the corporation. He was also my boss and my mentor. I was extremely grateful for his outstanding guidance.

"Keep your powder dry," he would say.

I didn't know what that meant. He explained that it meant stay calm, and don't let your anger show, or it will hurt your career. Unfortunately, people are all too quick to label someone as "the angry black woman," and that could become a hindrance to advancement.

Steve helped me to understand that you have to speak up and not accept something that's unjust. At the same time, you keep working hard with the understanding that it's ultimately going to pay off.

I also learned that if you believe you're not ascending the ladder quickly enough, don't put your head down and get negative about it. Instead, take on tasks and assignments that will get you noticed. Make yourself invaluable.

Speak up when necessary, but do so in a positive manner. That means, rather than merely pointing out a problem, propose a solution along with it. Keep fighting—in a diplomatic manner—for what you know you ultimately should have.

Steve also coached me on how to communicate effectively in meetings, when all too often, men would cut me off while I expressed my view on something.

"You are petite, you have a soft voice," he said, "and you are always on point. The next time someone interrupts you, put your hand out and say with authority, 'Wait a minute. I was not finished.'"

I followed his instructions, and it worked. My male colleagues never did that to me again.

As I continued to climb the corporate ladder, I sometimes felt isolated because I was often the only woman or person of color at my level. I watched the male managers and executives getting together for lunch, but I was never invited to join them. Then one day at DTE, one of the executives came by my office and said, "You know what? We never ask you to come and join us. It would be nice if you would sometime."

Though this occurred decades into my career, I was grateful that the spirit of diversity and inclusion that my company was cultivating had trickled down into a lunchtime invitation from my peers.

A Delightful And Shocking Surprise

In 1996, the American Association of Blacks in Energy (AABE) held its national conference in Detroit. I hosted the reception at our MichCon building, before the merger of Edison and MichCon.

AABE has been family. It's where I met some of my lifelong

friends, including the ladies writing their stories in this book. I recall attending my first national conference and being in awe to see so many African American professionals under one roof. My participation in the organization over the years was highlighted during the energy crisis. It was being felt across the country and the brunt of the impact was on low-income people of color. However, they were absent from the discussions and decisions as national policy was being developed. AABE formed to remedy that.

AABE's mission statement says that it aims: "To provide direct input into the deliberations and developments of energy policies, regulations, emerging technologies, and environmental issues."

As the organization began to implement its mission, chapters were being formed across the country. I, along with another senior-level executive at MichCon, partnered with our counterparts from Consumers Energy (the other large energy company in Michigan) to form the Michigan chapter of AABE. Having acquired my law degree, I wrote our first set of bylaws.

My leadership in AABE made me feel humbled and grateful for connecting with peers who felt like a small family and many new friends who shared a passion for social justice and community service. Over the years, I held various officer positions on the national board until I became term-limited.

Fast forward to the national conference in Detroit, which became one of my greatest memories. We worked to plan it, and in fact, sponsored the reception that was held at MichCon's corporate headquarters. Many of the executives stopped by, but had to leave due to MichCon's board meeting.

Following the reception, we went to a ballroom in the Renaissance Center—the largest hotel and conference facility in

downtown Detroit—for our formal dinner and program. As one of the organization's leaders, I was sitting on the dais. Along with a few others, I had played a major role in planning and coordinating the conference.

Suddenly my boss, Steve Ewing, who was now President of MichCon, walked in. I was puzzled about why he was there. I watched as he proceeded toward the stage and stepped up to the podium. Then AABE's board chair introduced him as if his appearance were a planned part of the agenda.

It wasn't!

At least, not to my knowledge.

"I'm here to announce what occurred at the MichCon board meeting today," Steve said. "Joyce Hayes Giles was appointed Vice President of Corporate Resources and will become an Officer of the company."

I was shocked!

I had no idea that I was being considered for this top leadership position. I was the first woman of color to receive this honor.

Upon hearing this news, my AABE brothers and sisters from across the country shot to their feet and gave me a standing ovation. That was the most memorable highlight of my career.

I then learned that Steve had, unbeknownst to me, shared the news with the AABE chairman, and made arrangements to publicly announce my appointment at the conference. Steve knew how much I valued and loved AABE, and wanted to make the announcement before an audience of my peers.

During this extraordinary evening, I remembered what Steve had said to me when I'd lamented that I felt passed-over for promotions by those less qualified and experienced.

"Continue to do a good job," Steve had told me. "Your hard work will be noticed. Your day will come."

On this night, I was immeasurably grateful that my hard work and commitment toward excellence had been noticed.

And my day truly had come.

Pay It Forward

Steve's exemplary role in my career as a mentor reinforced the commitment that I made early in my career to help others succeed. I've always believed that part of a leader's job is to make sure others are recognized. My mantra has always been, "If I help those under me succeed, they succeed, and so I succeed. We're a team. We work together." I became known as a quiet but strong leader, and a real leader of people.

I retired in 2013 after 35 years with the company.

Three Takeaways For Success

First, always have confidence in yourself and do the very best that you can, both for your career to excel and in ways to help others succeed. You can get a lot of pleasure, enjoyment, and fulfillment from helping others.

Second, focus on excellence, and never give up. When I was really disturbed by seeing people being promoted who had a lesser educational background, I could have easily become bitter. I could have given up or gotten angry. That would not have gotten me anywhere. People don't want to work with individuals who are always mad at the world. Eventually, all the hard work will pay off. It may not be when you feel that it should be, but it will happen.

I speak from experience; I first became an officer of MichCon

at a time when I was concerned that other people were being promoted while I was not. My career trajectory could have gone the other way, had I decided to do the least to get by. Instead, I maintained my professionalism and strong work ethic.

Third, be prepared for opportunities when they present themselves. You can do this through education and by being a lifelong learner. I did this by earning my bachelor's degree, followed by an MBA, then a law degree. And I maintained unwavering dedication to my work while simultaneously focusing on education and raising a family.

My formula for this is: PREPARATION + OPPORTUNITY = SUCCESS.

Community Service Creates Opportunities And Leaves A Legacy

A major part of my career focus and success was community service and focus on the customer. I had always felt inspired to invest my time and energy in helping people because I enjoyed it and because I felt called to serve the community. I later learned that this commitment evolved into a tremendous asset that accelerated my ascent up the corporate ladder.

Most notably, DTE Energy Chairman Tony Earley spearheaded my corporate leadership position because he wanted someone who could help build a culture of service to the community and to customers. With my promotion to Senior Vice President came the realization that my many years of community service had boosted my qualifications for this position. Corporations want good relations with the community, and they promote leaders who have built trust and provided benefits for the people they serve.

In fact, it was my early service on a community board where I first met Tony Earley. This impression was enhanced by my reputation in the community for what I was doing for MichCon in customer service.

When you're visible and a positive role model in your company *and* in your community, you stand out. Tony was willing to take a chance on me, even though I was ingrained in MichCon as an officer. He took a chance on me to come to the much larger company and change the culture. That's what he expected of me and I accepted that challenge.

One major cultural change occurred at a senior leadership meeting where corporate goals for the year were being discussed. I noticed that the top five goals had no customer-specific focus. We were primarily focused on the financial. I challenged why a top goal was not one of customer service. The ensuing dialogue ultimately resulted in our culture shifting to include customer service as a top priority. We began to realize that if you take care of the customer, the financial will follow. The takeaway from this is: don't be afraid to advocate for a cause or a principle that you believe is right.

This was another major highlight of my career.

All the while, I offered myself to the community as an extension of DTE. I chaired the DTE Energy Foundation, which empowered me to provide funding to major cultural, educational, and human services organizations. And I developed DTE Cares programs to get employees engaged in the community.

One program was Meals on Wheels. On many Christmas mornings, I joined committed company employees in visiting homes and delivering hot meals to many people, especially seniors who, but for us, would not have a hot meal or a hug or the presence of anyone

else on that day. That was special for me. We received a lot of recognition for that.

In addition, I was a board member for many nonprofit organizations. They included, to name a few, the Detroit Urban League, the NAACP, Music Hall, the Charles H. Wright Museum of African American History, and Henry Ford Hospital Health Alliance Plan (HAP). People always reached out to me and I was willing to help.

Because education was such an integral part of my success, I wanted more for the children in Detroit. I was able to provide the best education for my children, and I wanted the same for all children in our city. Rather than talking about how bad the public school system was, I ran for school board.

My CEO, Tony Earley, who was the chairman of DTE Energy at the time, fully supported me. When I told him why I wanted to run for school board, he wrote the first check for my campaign. The business community was so eager to create a good school system, that they put their full support behind me. The Detroit Chamber of Commerce fully endorsed me, and at my fundraisers, joined many businesses that wrote checks to ensure my success.

I was elected to the school board in November of 2005 and began serving in January of 2006. It was a tremendous accomplishment to campaign and become an elected official who was working to improve the education system. This was yet another major highlight of my career. I was, in essence, working two jobs. After a long day at work at DTE, I would put on my public official hat and attend a lengthy school board meeting in the evening.

The Detroit Public Schools Board of Education meetings were notorious for raucous debates and protests. However, I always remained calm during conflict. As a board member and a corporate

executive, I needed to serve as a respectable role model for the children attending these meetings. I wanted to show them how to handle conflict through diplomatic dialogue and a calm demeanor.

Unfortunately, many other adults failed to adhere to this code of conduct. In fact, one regular protester at our meetings actually threw something at us, and it hit me, constituting physical assault. I sued and won. My approach to dealing with this unacceptable behavior was in a court of law. The woman was banned from our meetings, and my victorious handling of the ordeal demonstrated how to calmly address violence through proper channels.

Along with community service, I believe in philanthropy and give my personal funds to many nonprofit organizations each year. I have also set up scholarship endowment funds in my name as part of my legacy.

In addition, I had an open door policy throughout my career. I mentored company employees, students, and people in the community. I do so because I want to see others succeed. I still do so in my retirement. This is one way I give back and pay it forward.

Mentoring people from all walks of life is rooted in my legacy of community service. I'm humbled by the amount of recognition I received during my career. It's also wonderful knowing that I am retired, but not forgotten. I was so grateful when the Detroit Urban League named me as one of its Distinguished Warriors at a gala awards ceremony in 2018.

The message here is to always do your best, because you never know who's watching.

Breaking The Glass Ceiling

Women remain woefully underrepresented in the CEO offices of energy companies, and in corporate America in general. I want the numbers of female CEOs to equal the magnitude of male CEOs, meaning that so many exist, we cannot count them. It would be wonderful to say that numbers are no longer an issue.

The next step above CEOs is the elite echelon of corporate boards, which have not opened up to women and people of color. I am very disappointed that opportunities have yet to materialize in paid positions on corporate boards.

From Growing Up In Mississippi To Traveling The World

I did not leave my hometown until college, except for family road trips to New Orleans as I was growing up. I wanted to broaden my perspective and have access to the cultures of the world, and thankfully, retirement has provided that opportunity, which I enjoy at full force.

My travels to many countries on several continents—including Israel, Argentina, Greece, Vietnam, Costa Rica, Cuba, Africa, Cambodia, and many more—have broadened my capacity to understand the world outside Mississippi, Michigan, and the US. Many opportunities exist in the greater world, as do fascinating, intelligent people.

As I celebrate the 70th year of my birth, I am extremely blessed and grateful that life has provided me with so many adventures that I never imagined as a girl growing up in segregated Mississippi.

I am grateful that my college-educated daughters and my granddaughter are experiencing a world with many more freedoms

and opportunities than I faced as a child. Today, my older daughter is a creative writer, and my younger daughter is working for a talent agency representing actors in Los Angeles. She's married with a three-year-old daughter, Winter, the love of my life.

As women in corporate America, we have come far, and I pray that my efforts and my story can help pave the way for continued progress toward a corporate arena where women and people of color are hired and promoted in proportion to our numbers in the general population.

May *The Energy Within Us* as a gender and as a race continue to burn brightly into the future.

Biography Joyce Hayes Giles

Joyce Hayes Giles was assistant to the chairman and senior vice president of Public Affairs for DTE Energy (NYSE: DTE), a Detroit-based diversified energy company involved in the development and management of energy-related businesses and services nationwide. She was responsible for a broad range of assignments related to the company's commitment to the community on behalf of DTE Energy Chairman, President and CEO, Gerard M. Anderson. She was chair of the DTE Energy Foundation, responsible for strategy and oversight. In addition, she served as the company's Chief Ethics Officer and the ombudsman for employee-related issues.

Joyce previously served as senior vice president of Customer Service for DTE Energy. Prior to that, she was vice president of corporate resources at MCN Energy Group, the former parent company of MichCon. She joined MichCon as Manager of Compensation in 1978. Through various director-level positions with the company, she led employees in customer relations, material management, administrative services, customer information, and physical assets. Prior to joining MichCon, Joyce was employed with the Automobile Club of Michigan, Chrysler Corporation, and Connecticut General Life Insurance Co.

Joyce earned a Bachelor of Arts in psychology from Knoxville College. She also earned a Master of Business Administration from

the University of Detroit and a Juris Doctor from Wayne State University Law School.

Joyce's professional affiliations include membership in the Detroit, State of Michigan, and Wolverine bar associations; the Women's Economic Club of Detroit, Leadership Detroit Alumni Association, Junior League of Detroit's Community Advisory Council, Delta Sigma Theta Sorority, Inc.; and The Links, Inc. She has served on both the local and national board of directors of the American Association of Blacks in Energy (AABE). In addition, she is actively involved in the community and has served on various boards, including past Board Chair of Marygrove College, the Urban League, and the NAACP-Detroit Chapter. Her current boards include Health Alliance Plan of Michigan, the Music Hall, Wayne State Alumni Association, Habitat for Humanity of Detroit, the Charles H. Wright Museum of African American History, Knoxville College, and the DTE Energy Foundation. She also served on the Detroit Regional Chamber's Nominating Committee and their Planning Committee for the annual legislative conference. She is the former Vice President of the Detroit School Board.

Joyce was honored by the Michigan Roundtable for Diversity and Inclusion as a 2012 Humanitarian for her efforts in the community to build relationships that create social justice. In October 2012, she was inducted into the Hall of Honor by the University of Detroit Mercy College of Business Administration, having been selected from more than 17,000 living alumni, as an individual who embodies the true meaning and spirit of "women and men in service to others." Joyce was named one of the "Top Influential Women in Corporate America" by *Savoy Magazine* and was featured in the Fall 2012 edition of this national publication. In March 2012, Joyce was recognized by the Historic Little Rock Baptist Church of Detroit as a

Woman of Distinction. In 2009, she was honored by Inforum as one of the area's most powerful and accomplished woman business leaders. She was the recipient of the Detroit Women's Club Professional Woman of the Year Award and also received honors from the UNCF Detroit Inter-Alumni Council. In 2008, Joyce was recognized by the *Michigan Chronicle* as one of the "Women of Excellence" awardees. In 2007, she was recognized by *Crain's Detroit Business* as one of Detroit's Most Influential Women, and was also presented the Political Service Award from the Fannie Lou Hamer Political Action Committee. In 2006, she was appointed by Governor Jennifer M. Granholm to the Mentor Michigan Leadership Council. She was also selected as one of the country's Most Distinguished Black College and University Graduates by *US Black Engineer & Information Technology* magazine. In addition, she was recognized in the Inaugural Edition of *Who's Who in Black Detroit* as one of Detroit's Most Influential Leaders. In 2005, she was awarded the Booker T. Washington's Two Way Street Award. She has also been recognized by *Corp! Magazine* as one of Michigan's "Most Powerful African American Leaders" and in 2005 as one of Michigan's "Extraordinary African American Achievers." She received the Lewis H. Latimer award from the American Association of Blacks in Energy. She was also selected for "Who's Who Among Black Americans" and was recognized by *Crain's Detroit Business* as one of Metro Detroit's Most Influential Black Business Leaders. In 2000, she was selected as one of the finalists in Grant Thornton's Executive Woman of the Year award. She was chosen as an Outstanding Young Woman of America in 1981 and received a NAACP 100 Club Award. On the national level, she made *Minority Business News USA's* list of "Women Who Mean Business" and Women's Informal Networks Most Influential African American Women for 1998.

A Circuitous Journey

by Carolyn Green

"I'm a success today because I had a friend who believed in me and I didn't have the heart to let him down."
—Abraham Lincoln

College & First Job

I think my career, unlike that of most of my friends, is similar to what young professionals today likely can expect. I haven't spent my career in one or two companies, or even in one industry. Instead, I have transferred skill sets from one job to another, building on my experiences and relationships to develop a fairly broad career portfolio that spans the public and private sectors and encompasses several industries, of which energy and environment are the most important.

An energy career wasn't something I set out to build. In fact, energy never entered my mind as I dreamt about my future, with possibilities as vast as: a high school band director; a journalist; a constitutional lawyer; an urban planner with a law degree; a developer of transportation models; and an environmental planner. In college, I was a true liberal arts student: a music performance major with interests in physics, engineering, economics, and history, with a healthy dose of political science thrown in.

So, where did it all begin?

I grew up in the home my parents built on land my grand-mother gave them. We lived next door to the house in which my mother was born in a northeastern Iowa working class city, where African Americans generally were expected to go to work in one of the factories in town. Nevertheless, my family expected my brother and me to do well in school and get a college degree.

Somehow, I absorbed a subtle but important message that I was unlikely to become a world-renowned expert in any one field, so I should become conversant in as many disciplines as possible. That emphasis on being well-read and well-spoken encouraged my natural curiosity, making me an avid reader and fearless in sharing my perspectives based on the information I uncovered.

My family also taught me to embrace new experiences. My mother, in particular, took me with her to meetings of the local NAACP chapter, the county political party, the League of Women Voters, and the National Council of Christians & Jews. As a result, operating within a non-minority environment, expressing my views, and politely defending my position became part of my DNA. Those early experiences taught me that community service is a responsibility, not an option.

My Uncle "Gene," my mother's oldest brother, was a sought-after tenor soloist throughout the north central Midwest. He had earned a degree in religion and music from Fisk University and began teaching my brother and me "ear training" and "sight singing" from a very early age. However, he had been blind since his early teens, so my family often drove him to his out-of-town engagements.

My uncle's notoriety and my mother's community involve-ment meant our teachers and the larger community assumed we

would do well. I was a natural test taker and loved reading, so I was placed on a gifted student academic track. My assumption was that I would get a music degree, like my uncle, and then return to teach band at my high school. Most black students, even those who excelled academically, were counseled to focus on "practical courses" that would allow them to get a job following graduation, which for me was teaching.

However, I was interested in all sorts of subjects and, for some reason, my guidance counselors encouraged me to get a well-rounded education so I would have a choice in where I went to college. Consequently, I took what would now be called AP English, Latin, science, and math, in addition to band, orchestra, and choir. I also was involved in student government, writing, and theater, and my friendships reflected my interests and involvements.

Coupled with living in an all-white neighborhood and attending an all-white elementary school, most of my junior and senior high classmates and friends were white, so my relationships with many black students were fraught with mutual distrust and lack of understanding. They accused me of being stuck-up and wanting to be white; I thought they were intellectually lazy and narrow-minded. I couldn't wait to leave town and go away to college. Fortunately, both the other black students and I realized, as we got older and our horizons broadened, that we all were doing the best we could with the cards we each had been dealt.

I realized as a college freshman that I didn't want to be a teacher or a professional musician, but until I encountered the university's nascent urban and regional planning department during my senior year, I didn't know how to integrate all my interests. The graduate program in Urban & Regional Planning allowed me to specialize

in "being a generalist." My graduate focus was transportation planning, mainly as a reaction to the professors voicing their assumption that women and students of color would concentrate on the "soft" disciplines of housing or social planning, rather than an "academically rigorous track" like transportation.

But even during the height of the Arab oil embargo, I didn't think about the connection between transportation planning and energy. As my professional career path became more clear, energy for me was inextricably linked to environmental protection. I'm fascinated by how production, distribution, and use of energy affects economic development, human health, and the environment.

I didn't know it at the time, but my introduction to the world of energy began at the California Air Resources Board (ARB to its employees) when I started my first professional planning job just a few weeks before the election of Jerry Brown as governor. In one of his early appointments, Governor Brown named a hotshot young environmental attorney to the ARB. Mary Nichols had recently won a landmark lawsuit against the US Environmental Protection Agency over its failure to provide guidance to states on how to guarantee progress toward meeting health-based air quality standards. In a nutshell, the plaintiff's argument was that, without a disciplined scientific process to measure emissions, predict their growth over time, identify actions to reduce those emissions and then enforce their implementation, EPA and the states could not satisfy their statutory requirement to protect public health. When Mary took on the task of developing an "air quality management plan" (AQMP) for California, I was one of the ARB staff members assigned to support that effort.

Talk about an urban planner's dream job! This was an opportunity

of a lifetime to build a plan that wouldn't just gather dust on a shelf. We engaged state and local government, EPA, industry (mainly utility and oil company representatives), and local communities in each key region of the state in the planning effort, despite skepticism from all sides over whether such disparate interests could ever be reconciled.

As a young, earnest, "white-sounding," and often brash African American woman from Iowa, I encountered disbelief from ethnic community leaders who repeatedly told me I was naïve and that air pollution was a "white man's issue." My rejoinder was usually along the lines of: "But the reason little JaQuan and Keisha can't read isn't that they're lazy; they can't read because their brains are being poisoned by the carbon monoxide and lead pollution that are worse in black communities!"

To almost everyone's surprise, we convinced all of those diverse interest groups to work together to adopt air quality management plans in Southern California, the San Francisco Bay Area, Sacramento, and the Central Valley. That planning process formed the basis for what would become Title 1 of the Clean Air Act Amendments of 1990.

Equally importantly for me, the AQMP development experience had two profound effects on my life and my career. First, in Mary I gained a role model, who later became a dear friend and collaborator. Secondly, I realized that I really enjoyed being part of the policy-making process. I usually am the person asking the *why* and *what-if* questions, as well as the person questioning assumptions and playing devil's advocate.

After almost three years with the ARB, I moved to Southern California, thanks to being recruited to work for the sole planning and engineering consultant to the Mission Viejo Company. If ARB

was an urban planner's dream, the Raub Company was planner's heaven!

We were charged with designing and securing approval for Aliso Viejo, a new 20,000-dwelling-unit community, from 6,700-plus acres of dry land farming, grazing, and open space. Not only did this project encompass the normal neighborhood, community services, and commercial/industrial design elements, but we also had to design all of the necessary infrastructure, including the water/wastewater, energy, and transportation systems.

As Policy Planning Manager, part of my responsibility was serving as alternate to Mission Viejo's VP of Planning on his many industry and public agency advisory boards. There was considerable overlap in membership of the bodies, so I got to know many of the industry representatives well, especially those from oil companies and utilities, little knowing that they would play a crucial role in my future. I also had to speak with community groups and regulators to convince them that our project would be good for the community and for the environment. My boss gave me some advice that has guided me ever since; he said, "Take the time to be brief." Making certain that I know the material well enough to communicate the important points succinctly—orally or in writing—has been extremely beneficial throughout my career.

About the time we successfully navigated Aliso Viejo through the local and state permitting maze, the bottom fell out of the housing market and I was laid off just two weeks before my wedding. Fortunately, I had been approached by a friend who had been promoted at Southern California Gas Company. He wanted to know whether I would be interested in his former Issues Planner job in SoCalGas's Public Affairs Department. It seemed like a good way to

get my feet wet in an operating industry, and I looked forward to doing something other than environmental planning.

I was assigned all sorts of public policy issues to review and develop proposed responses for senior management. These ranged from whether senior citizens should have their gas service disconnected for failure to pay, to how to combat retail wheeling (the forerunner of retail deregulation). In the process, I developed a reputation for asking insightful but uncomfortable questions, coming up with creative solutions to problems, and synthesizing seemingly disparate concepts and positions.

A reputation for probity and creativity was not necessarily positive within the company. Coming from the homebuilding industry, I was unaware how risk-averse utilities were, so I often challenged assumptions that I didn't know were actually sacred cows. One incident in particular comes to mind. At his retirement luncheon, the corporate psychologist named as his major accomplishment: "weeding out the corporate sociopaths," whom he defined as people with significantly different approaches to problem solving. Even though he mused that ensuring a homogeneous corporate culture was not necessarily the best outcome for the company, the fact that he named me as one of the "sociopaths," followed me throughout my tenure at SoCalGas. I was labeled a maverick in an organization that prized conformity.

At the same time I joined SoCalGas, one of my industry organization colleagues was hired to run the SoCalGas Environmental Affairs Program. When he was promoted, he named me as his replacement—the first woman, person of color, and non-engineer to take on that role. My team and I won several important battles with environmental regulators by approaching proposed regulations

or enforcement actions as problems to be solved, and proposing solutions that both the regulators and the company could live with. Ironically, though, senior management seemed to take the position that, if my boss had done his job, I would not have been so successful. What a backhanded compliment to me and an insult to my boss!

The year I became Environmental Affairs Manager, I also was introduced to the American Association of Blacks in Energy (AABE) by Berlinda Fontenot-Jamerson, SoCalGas's senior African American HR professional. Berlinda was chair of the AABE annual conference being held in Los Angeles, and she invited me to participate on the local conference planning team. Berlinda introduced me to her colleagues and friends at other energy companies throughout Southern California and to Rufus McKinney, an AABE founding member and the highest-ranking African American at SoCalGas. Rufus in turn personally introduced me to his fellow founding members, praising me much more than I deserved and encouraging them to answer my questions and, in essence, mentor me. The welcome and generosity of spirit that Berlinda, Rufus, and his colleagues displayed has stayed with me and still colors my involvement with AABE and my interactions with young professionals in the energy industry.

I enjoyed working at SoCalGas and learned a lot about natural gas distribution, but all was not roses. Twice when department heads recommended me to fill the jobs they were vacating, their vice president told me, "You'd be good in that job, but you're not reachable," because the job was three or four levels above my position at the time. However, the policy against giving anyone more than a two-level promotion was circumvented several times during my tenure by giving favored employees a temporary assignment and promoting them from there.

My experience wasn't unique, either, especially for African American women. We seemed to progress more slowly than our white and male peers—one level at a time—and hit a career plateau well below the senior ranks. One African American female, who had a BS in Chemical Engineering and an MBA, left a few years after I did and had a very successful career with another energy company.

Despite feeling that African American females were not being treated fairly by senior management, I assumed that I would build a career at SoCalGas. However, in what was to become a pattern of unsolicited opportunities, I was contacted by the South Coast Air Quality Management District. The AQMD, as it was known, was the local air pollution control agency for the Los Angeles region, and I was chair of its Technical Advisory Council. The new Executive Officer was reorganizing his senior management staff and asked me to sit on an interview panel for the Deputy Executive Officer for Planning & Analysis. After the panel unanimously rejected all of the finalists, the Chief of Staff asked me to throw my hat in the ring for the job, which represented a significant increase in both pay and responsibility. I was torn over whether to leave the company, but ultimately decided that the opportunity was one I was unlikely to get soon, if ever, at SoCalGas.

Mid Career

My tenure at the AQMD was much more closely tied to the energy industry than either I or my industry colleagues expected, mainly because of the intractable nature of the region's air pollution. Southern California had been long recognized as the worst in the country, despite having some of the toughest emission-control

requirements in the world. I was in charge of Planning and Rules, which put me at the center of the controversy surrounding the adoption of regulations and of the attainment plan itself. I knew we would need to impose ever-more-stringent requirements on industry, and I tried to make sure my staff and the board heard from all of the interested parties. These included the industries being regulated, environmentalists, and other governmental entities, of course, but also the communities affected not only by the pollution itself, but also by the cost of the emission reductions.

During my first 18 months, the board adopted several tough controls on oil company and utility combustion sources, and approved its first-ever regional air quality attainment plan (AQMP) for ozone and carbon monoxide (CO). The plan received almost 70 percent approval in public opinion polls, but the industry was outraged because, for the first time, our analysis clearly linked oxides of nitrogen (NOx) to ozone formation.

In Southern California, NOx came from two important sources: motor vehicles and large natural-gas-fired heaters, boilers, and turbines used mainly in the region's oil refineries and power plants. The two industries challenged the plan and disparaged AQMD staff's analysis, contending that, although we were bright and well-meaning, we didn't have access to the state-of-the-art photochemical modeling tools that would disprove our naïve theories about ozone formation. Imagine their consternation when, after spending $1 million to redo our modeling analysis, they came up with the same results we did. Our staff victory celebration was sweet indeed!

The other plan component directly affecting the energy industry was the CO attainment plan. Over 90 percent of the region's CO emissions came from automobile tailpipes, and we stated in

the AQMP that internal combustion engines could not be part of a clean air future in Southern California.

Within 30 days following the adoption of the plan, scientists at ARCO asked to meet with AQMD and ARB staff to demonstrate a new "reformulated" gasoline that immediately reduced CO emissions by 20 to 30 percent. The new gasoline, coupled with tougher tailpipe standards on new vehicles sold in the state, proved so successful that the region was able to meet the federal CO standard well ahead of the schedule we had identified. The EPA later issued federal regulations requiring reformulated gasoline in severe and extreme nonattainment areas nationwide.

This incident coalesced thoughts that had been rolling around in my head for several years and which now are a key tenet of my dealings with industry and regulators. Government can and should set performance standards that challenge technology to solve difficult environmental problems. Then they should allow industry to do what it does best: find innovative and cost-effective means to achieve the required performance in the real world. In the case of CO emissions, we did not know exactly how CO emissions could be reduced from automobile tailpipes; we just knew something needed to change. For their part, the oil industry chemists had never been asked to develop a less-polluting gasoline; their focus was on increasing octane to improve engine performance.

One additional AQMP component bears mentioning. Early in my career, ethnic community leaders had dismissed my requests to get involved in the air quality planning process, claiming that air pollution was a "white" issue. By the mid-1980s, however, the environmental justice movement was taking off, and communities of color wanted a say in what sorts of facilities would be built in their communities.

They also were increasingly concerned about the impact of air pollution control requirements on jobs in ethnic communities.

Until the 1987 South Coast AQMP, cost analyses of plans and regulations were limited to cost/benefit or cost/effectiveness analysis, using aggregated industry employment figures to compare the cost of health effects from pollution to the cost of reducing pollutant emissions. To be sure, industry regularly called proposed regulations "job killers," but their claims were not supported by the job data. In a regional economy as large as Southern California, macro-economic impacts of rules and regulations barely registered. However, ethnic and low-income communities were concerned that job losses were mainly among unskilled and semi-skilled jobs, which affected their communities disproportionately.

I had been active in community organizations over the years, and my office staffed the AQMD Advisory Council, so many of those leading the call for greater transparency regarding the real costs of the plan on communities of color were my friends. One organization in particular, The Ethnic Coalition (TEC) of Southern California, comprised young African American, Latino, and Asian professionals and academics who were determined to ensure that regional policies reflect the needs and concerns of communities of color.

TEC was particularly adept at translating community concerns into policy- and academic-speak so that agencies could not discount their input. I spent countless, sometimes contentious, sessions explaining the draft AQMP to TEC members and discussing what its accompanying Environmental Impact Review did and did not cover. The result of TEC's vocal and sophisticated intervention was the first-ever economic impact analysis of the AQMP—or any plan, for that matter. Such analyses of micro-economic impacts by

job type and by community are now commonplace. I certainly can't take credit for the analysis, but I'd like to think that those discussions with TEC members helped to crystallize the issues and highlight the importance of having a seat at the air quality policy table.

After we released the draft AQMD for public review, my husband Michael and I took a long-awaited trip to the East Coast to go "leaf peeping." Midway through our journey, I got a call from the Chair of the AQMD board informing me that my counterpart in charge of government and public affairs was being let go. He then asked me to take over the external affairs function and sell the plan that I had shepherded.

Ironically, this meant that I would become the in-house advocate for, among others, the very industries I had identified in the AQMP as needing to be further regulated. I accepted the job, and while being far from comfortable, the switch helped me hone my analytical skills and better recognize which arguments—internal or external—were real and which were red herrings. Heading Public Affairs also increased my comfort in explaining complex technical and public policy issues to diverse communities of interest and helping them find common ground.

With the successful development and adoption of the AQMP, I realized that all of my jobs to that point had been in organizations undergoing significant shifts in their focus. At the ARB and AQMD, it was developing the AQMP process and then managing the development of a plan to show that meeting health-based air quality standards in Southern California was possible. At the Raub Company, it was developing a new community rather than just designing housing subdivisions. At SoCalGas, we were facing the prospect of deregulation of our heavily regulated monopoly at

the same time that environmental regulations were forcing us to change the way we operated our business.

I learned that I thrive in fast-paced environments where the future is unknown, but where the mission is clear. I began seeing myself as a change agent and big-picture thinker who was bored with "business as usual." Although I understood that and emotional letdown usually follows the completion of such game-changing initiatives and accompanying increase in attrition, I realized that I had neither the interest nor the emotional makeup to shepherd my people through the daily grind of developing or implementing all of the individual rules and regulations called for in the AQMP. I was much more interested in the air quality policy debates taking place within Southern California, in Sacramento, and in Washington, DC.

As the AQMD began developing the rules and regulations needed to carry out the air quality plan, my staff and I were often buffeted by both internal and external forces convinced of the rightness of their individual perspectives. For industry representatives who thought we were moving too far, too fast to reduce air pollution at the expense of the economy, we were seen alternately as apologists for the rule and permit writers, or as shills for radical environmentalists. The environmental representatives, many of whom were personal friends, often viewed our compromises as selling out to the big polluters. The State Legislature increasingly viewed the South Coast AQMD as too powerful and out of control, especially since we had our own source of funding. And as Congress was debating major amendments to the Clean Air Act, California and the AQMD in particular were either held up as an example of how air pollution control ought to be done, or vilified for seeking clean air, no matter the cost to jobs and the economy.

For my part, I went on the speaking circuit, testifying before the State Legislature, representing the AQMD domestically and internationally at air pollution control symposia, and keynoting meetings of industry associations, environmentalists, and community activists. Although the specific topics might have differed, my bottom-line message was always the same: no one can represent your interests as well as you can, so you have to get involved.

I usually told my audiences, "If you're not at the table, you'll find yourself on the menu." Interestingly, I was most popular with the energy trade groups, who said that, even though they didn't like my message, they appreciated my industry knowledge and experience, as well as my candor. But I was most proud of the fact that I was able to convince my AABE colleagues that environmental quality was important to the communities we represented and that we had a unique contribution to make because our members spanned the breadth of the energy industry.

At the beginning of 1991, I received a call from a Sacramento lobbyist friend who wanted me to talk with a headhunter about a job in the oil industry. In some ways it was a repeat of my Raub Company recruitment experience. I wasn't looking to leave the AQMD, and I certainly wasn't interested in working for the oil industry.

Between my disinterest and my travel schedule for the AQMD, I didn't actually speak with the headhunter for six months, at which point I told him I would try to recommend someone more appropriate for the position. Finally, in September, I grudgingly agreed to meet with a representative of the company, which operated a relatively small refinery in the Los Angeles harbor community of Wilmington.

My research said that the company had a good history of

meeting regulatory requirements. They were looking to fill two newly formed positions: Government Affairs Manager and Public Affairs Manager. I liked the people with whom I interviewed much more than I had expected, but I made it clear that I would consider either position a step backward. To my surprise, they responded that, based on my experience, they would be willing to combine both positions into one and increase the salary.

What really sold me on the company, however, was Ultramar's President, Jack Drosdick, who met with me for about a half hour. I went home and told my husband, "I want to work for that guy." Besides the razor-sharp intelligence that I figured every CEO needed, he had a core strength and decency that spoke to me. I think what cinched it for me were his reasons for establishing a formal government and public affairs function within the company. He wasn't interested in publicity, but rather in making certain the company was doing the right thing and communicating appropriately with regulators and the community surrounding the refinery. I sensed that I could learn a lot from this man.

Ultramar was completely different from my previous private sector employer, SoCalGas. It was a maverick within the oil refining and marketing industry, and largely operated under the radar with a few important exceptions. I immediately bonded with several of my colleagues, and we formed an effective team for taking on a number of potentially explosive issues. Ultramar and ARCO were the only refiners to support the reformulated gasoline specifications, and together we prevented the trade association from publicly opposing its use statewide. We also went against the industry to support adoption of both reformulated gasoline and low-sulfur diesel specifications in Arizona. And as one of the largest industrial

power users in Los Angeles, we undertook the design of a cogeneration facility that would allow us to use our waste heat to produce our own electricity, which we reasoned would be cheaper and more reliable than the service we were receiving from the Los Angeles Department of Water & Power (DWP).

We had our share of "oops" as well, but our policy of being forthcoming and transparent stood us in good stead when a storage tank of heavy, sour crude oil split open, shutting down a major port entry road that ran through the refinery. On another occasion, a large construction crane was being transported from one location to another inside the refinery when the tractor tires went off the roadway and the rig tipped over. The crane fell across the Union Pacific Railroad tracks, narrowly missing the guard shack in which a UP security guard was finishing his lunch. It also destroyed the two southbound travel lanes of a bridge that was on the other side of the railroad tracks. Both of these incidents were costly, but we were fortunate that no serious injuries occurred, and we didn't suffer any lasting damage to our reputation as a well-run facility.

While at Ultramar, I was appointed by Los Angeles Mayor Tom Bradley to the board of the Metropolitan Water District (MWD) of Southern California, where I served on the Engineering and Finance Committees during the planning and design of the Diamond Valley Reservoir, which doubled Southern California's surface water storage capacity. Although I had a little familiarity with water supply issues from my days at the Raub Company, I had no idea how closely linked water and energy issues were. I was shocked to learn how much energy is needed to pump the water from Northern California over the mountains so that it can flow down into the Los Angeles basin.

I upset several MWD apple carts by asking questions and making policy recommendations, which evidently was not done until members had been on the board for at least five years. In fact, the joke was that change occurs in the water industry in geological time, so many longtime board members looked askance at the upstart from the City of Los Angeles. However, I knew several members of the Orange County delegation from my days at the Raub Company, so I was able to forge cooperative relationships across jurisdictional lines on contentious issues.

More importantly, Mayor Bradley's successor, Richard Riordan, retained me at MWD and later added me to the DWP Board of Commissioners. I took over as President of the board when the sitting President left to successfully pursue his dream of becoming the first civilian in outer space. Even though, as a municipal utility, we were not regulated by the state Public Utilities Commission, we knew that deregulation of retail electricity in California was just a matter of time. We also understood what an attractive takeover target we were, despite billions of dollars of debt associated with (mainly coal-fired) power plants whose value had plummeted.

In keeping with the utility industry's "belt and suspenders" approach to ensuring generation and distribution reliability, the DWP had considerable excess capacity in coal-fired power plants at a time when air pollution control regulations and access to cheaper natural gas were making gas-fired turbines the preferred option for new capacity. DWP had two additional, very attractive resources—our geographically compact, but large customer base and our transmission system. We decided that if we couldn't join the investor-owned utilities, maybe we could beat them. We chose to look for a strategic marketing partner to go after the non-regulated wholesale

and transmission markets. Not surprisingly, one of the finalists was Enron, which already was making waves in energy deregulation and was an active participant in the state legislature's debate over legislation to deregulate the California retail electricity market.

In the middle of all this, three events occurred at Ultramar that would affect my career in the future. First, at the eleventh hour, Union Oil of California backed out of a planned purchase by Ultramar. I had been working closely with Jack Drosdick to prepare for the announcement, identifying which regulators and elected officials we needed to notify in advance, drafting the press releases and fact sheets, and preparing Jack for the media attention the announcement would bring.

Everyone was understandably disappointed when the acquisition fell through, but we were stunned when a week or two later, Jack's departure was announced. When I arrived in the office on Monday morning, Jack's executive assistant took me aside and told me the bad news. I suspected at the time that someone had to take the blame for our failure to close the deal, and Jack was the sacrificial lamb. Our entire management team was upset over Jack's departure; and I wrote him a personal note saying how much I respected him, and that I would be honored to work for him again if the opportunity presented itself.

The second incident happened outside the company, indeed outside the oil industry. In April 1997, I happened to read an article on the front page of the *Wall Street Journal* reporting on the suicide of an African American woman utility industry executive. I had met Dianna Green through AABE and considered her a role model. I didn't know her well, but I liked and respected her, so her death shocked and saddened me.

At the next AABE board meeting, several female members decided to meet for lunch to talk about Dianna's death and offer each other support. All of us were the only or one of just a few African Americans and/or women managers in our respective companies, and we all shared a sense of isolation. That group of women has remained close to this day and forms the nucleus of women whose stories are told in this book. I'm convinced that my career in energy would not have been as productive were it not for the friendship and support of that group of AABE women who considered Dianna's death a wake-up call. We pledged that her legacy would be a sisterhood of sharing and support, not only for each other, but also for any other person of color we encountered in our companies and professional organizations.

Lastly, within just a couple of months after the collapse of the Unocal acquisition, Ultramar and Diamond Shamrock, based in San Antonio, announced their agreement to merge into a new company called Ultramar Diamond Shamrock (UDS). Given all of my involvements in California, and Los Angeles in particular, I was very reluctant to move, especially to Texas. The new UDS senior management team put on a full-court press to convince us that I should stay with the company, including flying us to San Antonio to meet some of the Shamrock folks and tour the city.

After considerable conversation and soul-searching, Michael and I decided that I should accept the UDS offer to become Director of Government & Public Affairs for the new, combined company. Even though we would need to move to San Antonio, the company's involvement in California would allow me to maintain most of my California relationships. In fact, they were seen as an asset, so for the next six months, I spent most of my time in San

Antonio, but went home every other week, both to see Michael and to continue my service at DWP and MWD.

One of my California friends called one day to ask if I would meet with representatives of Enron regarding the strategic partnership DWP was seeking. He and the Enron team flew to San Antonio, where we met over breakfast. Of the four Enron employees, it appeared that the lone woman was in charge. When she asked what Enron needed to do to be more competitive, I responded, "Do you want a political answer, or do you want the truth?"

After several seconds of shocked silence, she indicated that I should give them the truth as I saw it, whereupon I proceeded to tell them why they were not our top choice and would not be selected as our partner. In essence, I said that the Enron representatives were arrogant, inexperienced, and insensitive, not attempting to understand DWP's operations and why we operated the way we did. A strategic partnership was supposed to be between equals, but they approached us as conquering heroes, which did not endear them to our staff. Needless to say, when I finished talking, everyone was silent—until the woman started laughing. She acknowledged the truth of my comments and thanked me for my candor. For my part, I felt I had nothing to lose by being honest, but the Enron folks needed to know how they were perceived.

I spent two years with UDS. I liked San Antonio, where we made friendships that continue today, but I didn't understand or appreciate the Diamond Shamrock culture. During that time we bought the US holdings of the French oil company Total. My feeling was that we bought their service station network and paid for it by having to take their problem refineries. We shut one down, sold one, and the remaining refinery still operates. We also bid on the

Texaco Refinery in Anacortes, Washington, which we lost to Tesoro.

While on a visit to the Anacortes refinery, I found out how little I fit in with the Shamrock insiders when the Chairman asked me about my Government Affairs Manager. I responded that I thought she was a valuable employee who was doing an excellent job with the Texas Legislature and industry trade group and that she deserved to be promoted. He expressed surprise, saying that he had heard that I had tried to undermine her effectiveness. Needless to say, I was stunned and listed several actions I had taken on the employee's behalf. I strongly suspected where the rumor had started, but decided it wasn't worth engaging in open warfare.

I'd like to think that I improved the professionalism of the UDS government affairs program. At a minimum, I put the Diamond Shamrock lobbyists on notice that I expected them to understand the issues important to the company, not just use their relationships to open doors. I was most proud of the work we did to introduce cleaner fuels to the South Texas market. Both San Antonio and Austin were on the cusp of violating the health-based ozone standard. UDS suggested several voluntary measures, including the use of low-sulfur gasoline, to prevent the region from slipping into nonattainment. We argued that reformulated gasoline, which had to contain MTBE—a known carcinogen—during the smog season, would be an unnecessary threat to the region's groundwater supply. Low-sulfur gasoline with a lower vapor pressure would achieve the same air quality benefit without MTBE's groundwater contamination problems.

Oddly enough, although the environmental community supported our arguments about MTBE use in the extremely porous Edwards Aquifer, they opposed the use of voluntary measures to

remain in attainment. They appeared to prefer that the region become nonattainment so that any measures would be legally enforceable. They also argued that a voluntary control program could not be recognized by EPA. UDS convinced the local council of governments and air pollution control agency to hold a symposium on voluntary measures and low-sulfur versus reformulated gasoline. I reached out to my friend Mary Nichols, who had recently completed a stint with the Clinton Administration as EPA Assistant Administrator for Air, and was able to convince her to be a speaker. Her matter-of-fact, approachable style was exactly right for the skeptical South Texas policymakers.

I also think that, as the company's representative to many of the community organizations, I provided a more diverse face for the company. People in San Antonio, especially my Diamond Shamrock colleagues, certainly were surprised by my interests and background. I don't think most of them had met an African American who was not a Texan or Southerner, who was an unapologetic Democrat living in a district that didn't field Democratic candidates for state or federal offices, and a lover of the arts, especially classical music. They were even surprised by my answer to the question, "Where do you worship?" Clearly, they were not expecting me to be an Episcopalian. Nevertheless, people seemed truly surprised when I announced my resignation just before Christmas of 1998.

Enron To Entrepreneur

I was in Washington, DC in September of 1998 attending the AABE Board meeting and Congressional Black Caucus Legislative Weekend, when several MWD employees asked whether I had heard the news.

"What news?" I responded.

"Woody Wodraska announced his resignation!"

Woody, who joined the MWD as General Manager during my second year on the Board, had become a close working ally and friend, so I made a note to myself to call him on Monday when I was back in San Antonio. But just as I was looking for his telephone number, Woody called to tell me about his new career adventure. He had been hired to head the North American operations for Azurix, a new water marketing company that Enron was forming, and he wanted to know whether he could recommend me for the Vice President of Government Affairs position being created.

I said yes.

The next day a headhunter called. After our hour-long conversation, he said, "I have to tell you, in addition to your MWD and DWP experience, if you had said 'water' for each time you mentioned your experience in air quality, I would tell my client to search no further."

My response was, "With all due respect, your client needs to decide whether they want skill sets or previous job titles."

In this a-ha moment, it appears that was the best response I could have given. The next day, he sent me a job description that looked like it could have been written from our conversation!

In preparation for my interviews, I reached out to one of my Ultramar colleagues for a reference, which he graciously provided. He also urged me to stay in touch and told me that he and several other members of the Ultramar team had joined Jack Drosdick at Sunoco, where he had been hired as President and COO, with the understanding that he would become CEO when the incumbent CEO retired.

Two encounters during my interviews convinced me that some higher power was at work guiding my career. The first was that when I requested biographies of the persons who would be interviewing me, I noticed the Enron hiring authority had degrees from Iowa State and University of Iowa, which told me he was likely an Iowan. Before he could begin interviewing me, I quizzed him and found out that our high schools were football rivals. His polite greeting quickly turned to delight at meeting a fellow Iowan.

Then when I went to interview with the Azurix team, imagine my surprise at finding that the Azurix hiring authority was the woman who had headed the Enron delegation I met with two years before! Both meetings certainly awakened the policy wonk in me. Enron was looking to deregulate the water industry similarly to how they had changed the electric utility delivery model. I left feeling that this was an opportunity to be part of an exciting and potentially game-changing new direction for the water industry.

I was offered—and accepted—the job, which was especially important because of the differences between the water and electric utility industries. Whereas 85 percent of electric utilities in the US were investor-owned, the opposite was true of water delivery. Well over 85 percent of the water supply in the US was controlled by public agencies, so Government Affairs was at the center of Azurix's strategic marketing efforts.

After about four months on the job, I was also given responsibility for Regulatory Affairs in North and South America and inherited a staff of young, extremely bright attorneys and economists who were unaccustomed to thinking and writing for business rather than academia. Helping them hone their analytical skills by asking such questions as, "Why should I care about this?" or "What

is the value proposition?" was a major joy of my job, although I doubt whether they found my questions as satisfying. I tried to help them learn to write for decision-makers by questioning the relevance of each point they raised in their analyses. I reminded my team that decision-makers are very busy people who do not have the time to sort through dense material to figure out what is useful and what is just interesting. They want to know what the issue is, what decision they're being asked to make, and why. If they want more detail, they'll ask for it.

My staff members still tell me that my "Socratic" management style really helped hone their writing and analytical skills.

Four months after I started work, Azurix went public, with Enron owning the majority of the stock. It quickly became clear that Enron had turned their attention toward growing the energy and broadband trading business lines, which they identified as using *intellectual capital*; they appeared unwilling to allow Azurix to spend the money needed to be viable. We felt like we were just the cash cow to fuel the broadband growth. As an employee of both Enron and Azurix, I attended several senior management retreats where Azurix, with its reliance on asset-backed transactions, was derided as out of step with the 50 to 100 percent equity gains of Enron Energy Services or Broadband.

I found Enron to be one of the most exciting and intellectually stimulating places I have ever worked. There was an attitude that everyone there was the best and brightest, as well as a sense that we were making history, which was very empowering for self-starters.

On the other hand, I was experienced enough to recognize that an environment like that is often a burnout waiting to happen. I also sensed that many employees were beginning to believe

their press, which is always dangerous. That sort of hubris can lead people to take ill-advised chances, which is to be expected in an organization dedicated to changing the way major infrastructure markets worked. Unfortunately, there weren't the necessary checks and balances in place to recognize when people had gone too far and to rein them in. I was not aware of the risky practices and creative accounting that destroyed the company a year and a half after I left, but I wasn't particularly surprised when I heard the news.

Meanwhile, true to his word, my Ultramar colleague contacted me as soon as Jack was elected President, CEO, and Chairman of the Board of Sunoco. My friend had just been named General Counsel, another colleague was the Senior VP for HR and Public Affairs, and a third was Senior VP for Marketing. Within a few weeks, the new Chief Administrative Officer contacted me to say that the VP for Health, Environment & Safety (HES) was retiring. He wanted to know whether I would be interested in interviewing for that job. I let both Enron and Azurix know that I would be talking with Sunoco.

My boss at Enron wanted me to allow the company to make a counter offer, but my superiors at Azurix strongly encouraged me to get out if I had a viable job offer. I knew things were bad; Enron had moved my staff and me back into Enron, ostensibly to reduce Azurix's overhead costs, but I was shocked at how bitter the Azurix folks were over Enron's handling of the company. Azurix was always in the back of my mind as I talked with Enron management about my career options.

The position Enron offered was Executive Account Manager, which Enron was instituting to make certain that key energy services clients remained happy. The person would be the single point of

contact for at least one major multinational energy contract holder and have responsibility both for ensuring that the client received the agreed-upon services and for upselling additional products and services. It would require 60 to 80 percent travel, including internationally, and likely would be a promotion. The opportunity was intriguing, but I had one major concern. I didn't believe that customer care was part of the Enron DNA, so I asked what would happen to me if, a year or two down the line, the company turned its attention back to deal-making. Needless to say, I wasn't comforted by the non-specific platitudes I received in response.

Apart from my concern over the long-term viability of the Enron position, I was leaning strongly toward taking the Sunoco job. I had enjoyed my time in the oil refining/marketing industry and Sunoco appeared to be cut in the same maverick mold as Ultramar. I was particularly intrigued and impressed by Sunoco's fledgling Environment, Health & Safety and Ceres Review report, which the company had begun publishing just a few years earlier. And given my environmental regulatory experience, I relished the challenge of building upon what I viewed as a culture of environmental stewardship. Finally, I was looking forward to reconnecting with my Ultramar colleagues who had chosen not to be part of the Ultramar Diamond Shamrock organization. There were personal considerations, as well.

Although we really liked our townhome and Houston's cultural life was far richer than we had expected, Michael was not a big fan of Texas. If we weren't going to be in Southern California, he preferred having four seasons. Neither of us liked the heat and humidity of south Texas, or Pennsylvania for that matter, but we figured

that the summer would not be as long or intense in Philadelphia. And growing up in Iowa and western New York (think lake-effect snow!), we both were accustomed to winter weather. As I often observe to friends, "I can always put on more if I'm cold, but there's only so much I can take off when it's hot!"

Besides, being on the East Coast would put us within driving distance of Michael's parents, who were getting older and beginning to face health challenges. So, for the third time in four and a half years, we were moving or, rather, I was moving and leaving Michael behind to pick up the pieces of our lives. Not for the first—or last—time, I thanked God for having married an interior designer!

I spent almost nine years at Sunoco, the longest time in any organization, private or public. In many ways, Sunoco mirrored the under-the-radar-screen activism of Ultramar. Like Ultramar, the company supported the use of low sulfur, low vapor pressure gasoline. The Jewish community had an historically deep loyalty to Sunoco because we didn't use Middle Eastern crude oil. The company also had a solid and productive relationship with the environmental community, thanks to its longstanding relationship with Ceres, a coalition of environmental and investor organizations working to advance sustainability. As the first Fortune 500 and only oil company to endorse the Ceres Principles in 1997, Sunoco had built a reservoir of goodwill, mainly through the yearly *Health, Environment & Safety Review and Ceres Summary Report*.

With the retirement of both Sunoco's charismatic CEO and its VP for HES, Ceres leaders were understandably wary about their future relationship with the company. And as an East Coast-based organization, they had no history working with either Jack or me. In another series of *small-world* encounters, I was able to establish

credibility surprisingly quickly. First, the Natural Resources Defense Council was holding a fundraiser in Los Angeles, at which the Chair of Ceres and several of my West Coast environmental friends were being honored. I had Sunoco buy a table and invited my friend, Mary, as my "date." Not only did I have great time catching up with my West Coast friends, I was able to meet the Ceres chair on my own turf, where she could observe firsthand how I was viewed by her environmental activist colleagues.

The second occurrence was my meeting with Ceres' President, Robert Massie, at their headquarters in Boston. We immediately clicked and had a very cordial discussion ranging from environmental regulatory policy, community involvement, and environmental justice to arts and culture. After a tour of the Ceres offices, Bob received a must-take call and deposited me in his office, where I perused the photos on his wall, including one with Archbishop Desmond Tutu. When he returned, I pointed to the photo and said, "You're an Episcopal priest, aren't you?" Not only was my assumption correct, we discovered that he graduated from seminary with the rector of my church in Los Angeles! Such seemingly random associations have occurred throughout my career, helping me build working relationships across industry and geographic lines.

Sunoco's relationships with Ceres and with state and federal agencies occupied much of my attention. Our yearly performance reports, which eventually became a Corporate Social Responsibility report in all but name, were reviewed prior to publication by a committee of Ceres members who examined our performance numbers with a fine-toothed comb, especially those related to workplace injuries, permit violations or greenhouse gas emissions. Ironically, their most common criticism was we were being too hard on ourselves

in describing our accidents and mistakes. Although we appreciated the support, we knew that our reputation for forthrightness and transparency would be compromised if our readers felt that we were downplaying the seriousness of our incidents. During my time at Sunoco, we took advantage of the rapid growth in internet access to produce an increasingly more comprehensive, but at the same time more accessible, HES report.

I had mixed success within Sunoco. The external relationships that originally had been viewed as a strength increasingly came under fire from members of the senior management team who thought my sole focus should be internal. At the same time, the HES governance pendulum was swinging from a strong corporate program to a decentralized program run by the business units. The new Senior VP for Refining was the major advocate for this change. He was an experienced refinery operator, having turned around performance at several problem refineries, and he distrusted government in general and environmental regulators, in particular. Needless to say, we rarely saw eye to eye. More importantly, as the head of the largest business unit, his hands-on and detail-oriented management style appeared to become the default style. My more collegial coaching style, which had always been a major strength, became a perceived weakness.

In retrospect, I should have tried harder to find common ground with him and the other functional unit heads; instead, I allowed him to label me as being too sympathetic to the regulators and unfamiliar with day-to-day operations. Even though I often worked closely with refinery and chemical plant HES staff to find solutions to regulatory issues, I didn't defend my activities and my positions forcefully enough. Especially in senior management ranks,

giving credit for successes and taking blame for mistakes can backfire, particularly for a non-engineer in an engineering-dominated organization. I understood how my department head at SoCalGas must have felt when the success of my staff was labeled as a failure on my part. However, I was unwilling to change my style because it worked for me and for my employees.

Even though I had difficulty selling myself to Sunoco senior management, I continued to enjoy very high credibility outside the company. In addition to Ceres, I represented the company on industry and regulatory committees, including national refining and chemical industry trade associations and the US EPA. I even chaired one of the Chief EH&S Officers Councils for the Conference Board. And, like many sole women and/or persons of color on a corporate management team, I had numerous invitations to serve on nonprofit boards.

Ironically, these involvements gave me greater credibility with and access to the Sunoco board of directors than I otherwise may have had. The board members valued my broader energy industry perspective. They also valued my ability to communicate complicated issues and to know how much information to convey. My boss, who as Chief Administrative Officer put together the monthly board packages, often asked me to rewrite briefings authored by other Vice Presidents. In general, I ignored much of the Executive Team and continued to pursue those strategic issues that I believed were critical to the company's long-term survival, communicating my perspective to the CEO and Board, and running interference on Sunoco's behalf with regulators and industry and environmental groups. At the same time, I made certain that I supported and protected my department heads who interacted with the facilities on a

daily basis. Looking back, this was not the best way of dealing with the senior team, but it worked for me at the time. It also empowered my department heads to develop their staff and engage with line managers because they knew I was there to coach, encourage, and go to bat for them when necessary.

Although I could easily justify them as being in the company's interest, two organizations became my personal safety nets: AABE and the Executive Leadership Council. ELC was an invitation-only organization of senior African American executives from Fortune 500 companies. Sunoco's African American board member and a vice president who retired only a few months after I joined the company were both founding members of ELC, and both sponsored me for membership. As soon as I was inducted into ELC, I began lobbying my AABE colleagues to join as well and nominated them for membership.

Inside Sunoco, I convinced each of the business unit heads to identify one or two high potential employees to join me at Sunoco's table for the yearly ELC Awards Gala and accompanying Mid-Level Managers Symposium. Corporate covered the cost of the Gala and the MLM Symposium registration, so the business unit only had to pay travel expenses. As the company's only ELC member, I hosted the attendees, along with a different business unit leader each year, and made certain that our African American board member and his wife visited the table to meet everyone. Because of Sunoco's far-flung service area, the attendees often were meeting each other, the business unit head, and the Sunoco board member for the first time. Attending the Gala, seeing and meeting CEOs and senior executives from other oil companies, and then being in a management symposium with almost 1,000 other high-potential African

American middle managers, was a life-changing experience for our employees, and attendance became a sought-after honor.

At the same time, I was progressing through the AABE board ranks, eventually becoming National Board Chair in 2007. My AABE and ELC colleagues, especially the women, became my kitchen cabinet and, in addition to Michael, my emotional support. I used my friends as a sounding board and offered to be the same for them.

Outside of those two organizations, I continued to have a strong connection with my friends in Southern California. My friend Mary and I had started an informal, multicultural, multi-generational group of women environmentalists, and whenever I was in town, we resurrected our tradition of catching up over breakfast, a practice that continues to this day. AABE, ELC, and my "Enviro Women" kept me apprised of energy and environmental developments across the nation and, contrary to the beliefs of the Sunoco management team, made me more valuable to the company in my role as the Health, Environment & Safety thought leader.

The accomplishments of my fellow AABE and ELC members, as well as my "Enviro Women" friends, reinforced my belief that African American men and women have both the ability and the experience to run major energy and environmental organizations. But while being an executive of major corporations and agencies is important, true wealth creation lies in ownership, and I saw very few African Americans who owned businesses in the energy or environmental industries. Jobs create income; business ownership creates jobs and, if managed correctly, intergenerational wealth.

I began wondering why so few African American executives were taking the entrepreneurial plunge. Talking with members of the National Association of Investment Companies, an organization of

minority private equity firms or equity firms that serve the minority community (euphemistically called "the emerging domestic market"), I learned that most equity firms of color steered clear because they didn't understand the industry. That realization pointed the way toward my next, post-Sunoco adventure.

In August 2008, Jack Drosdick announced his intent to retire by year-end. Since I had been part of Jack's management team, I knew that it was unlikely that I would be retained by the new CEO. Moreover, there was only one potential position that I would want—VP of External Affairs—but I knew it would be a great longshot because the position didn't exist within the company. That realization made my conversations with the new CEO much easier.

In fact, because I wasn't fighting to keep my job, she became a supporter, allowing me to name my departure date and implement two initiatives that she agreed were important for the company. One was to transform the HES Report into a formal Corporate Social Responsibility Report, and the other was to publish a third-party verifiable greenhouse gas emissions report. Both initiatives would position Sunoco as best in class for environmental stewardship. At the same time, I was conducting market research and due diligence for starting a private equity fund to invest in lower middle market companies in the energy, environmental, and clean technology industries. I defined clean tech as making energy and environment cleaner or more efficient. I named my company EnerGreen Capital Management to reflect my investment emphasis and my name and gave myself two years to find an investment.

I am now majority owner in two companies. One, Professional Environmental Engineers, is a St. Louis-based company with 31 employees housed in offices in several Midwestern cities and

Houston. Although we perform environmental assessments and compliance assistance across the environmental spectrum, PE's sweet spot is hazardous waste. We identify and quantify the amount of pollution on a given site, analyze its degree of risk to the public health or the environment, and design a program to clean it up. For the most part, we don't do the cleanup ourselves, but we do oversee the work of the remediation company and document their progress and results. Our clients range from small developers wanting to sell a commercial or industrial property to local/state/federal government agencies who have multi-acre cleanup issues. PE worked on the massive lead Superfund site in Omaha, Nebraska; the Historic Jazz District cleanup in Kansas City, Missouri; and the Enbridge oil spill in northern Michigan.

The other company, Casa Verde Energy Services, is an efficiency-based energy services company, or ESCO, headquartered in Houston. Casa Verde currently has seven full-time and two part-time staff who: conduct energy audits for residential, commercial, and local government clients; design energy efficiency programs; and act as onsite supervisors to install efficiency measures. Both companies collaborated on a high-profile demolition and decontamination project following Hurricane Harvey, and Casa Verde continues to work with homeowner associations trying to recover from the devastating floods that accompanied the hurricane. We work with the HOA and with individual owners to make certain that their remodeled structures meet or exceed current energy efficiency building code requirements.

Worrying about making payroll and having a large enough business pipeline to keep employees engaged is very different from my life in corporate America. And, as the owner, the first salary to be cut in down periods is mine. I no longer have a large administrative

base to support me because small businesses can't afford to maintain a non-revenue-generating employee infrastructure. I find that I have to solve problems myself, outsource administrative functions, or ask senior managers to perform multiple administrative functions in addition to their regular, technical responsibilities. I also have learned that I would much rather think strategically and talk with potential clients than deal with the often-mind-numbing minutiae of day-to-day management.

So, do I regret taking the entrepreneurial path at the end of my career? No, absolutely not. It challenges me in ways that I never would have imagined. In many ways, I wish I had struck out sooner, when my life wasn't so filled with obligations, when I still had time to fail and start over. Being an entrepreneur now is much more risky because, if I fail, retirement will be much more difficult.

On the other hand, it has taken a career to gain the subject matter expertise, the perspective, and the network that make this gamble winnable. Besides, I'm not certain I ever want to "retire" in the sense that I step away from the work world entirely. I see myself pulling back some—in ten years or so—but I find I need the intellectual and social stimulation of the work world. I also want to help shape the next generation of entrepreneurs by mentoring, especially African American women who may be contemplating embarking on this path. More and more, I appreciate being one of the "Aunties" to whom younger people look for wisdom and advice.

Mine has been a nonlinear and unpredictable career path, and I certainly have made mistakes, but it has afforded me experiences that I could not have imagined as a young girl. More importantly, it has brought wonderful, bright, stimulating people into my life. To me, that's the definition of success!

Biography Carolyn Green

Carolyn Green is Managing Partner of EnerGreen Capital Management, which she founded in 2009 to invest in late-venture and early-growth-stage companies involved in the energy and environmental industries. EnerGreen's largest holding is Professional Environmental Engineers, Inc., a full-service environmental engineering and consulting firm, where she serves as President and Chief Executive Officer. Based in St. Louis, MO, PE also has offices in Kansas City, Chicago, and Houston. The company provides environmental assessment, compliance, and remediation services to public and private sector clients nationwide. EnerGreen's holdings also include Casa Verde Energy Services, LLC, which offers energy assessment and efficiency solutions and construction management services to public and private sector clients in Texas, Louisiana, and Arizona.

Carolyn has over 35 years' experience in the energy and environmental industries, most recently serving as Vice President of Health, Environment and Safety for Sunoco, Inc. As the company's chief sustainability officer, her duties included environmental compliance, corporate safety and security, liaison with regulatory agencies, environmentalists and community groups, and documenting and reporting on the company's environmental and safety performance, energy use, and greenhouse gas reduction program. She also has held positions as: Director of Government & Public

73

Affairs for Ultramar Diamond Shamrock; Environmental Affairs Manager for Southern California Gas Company; Deputy Executive Officer for the South Coast Air Quality Management District; and President of the Los Angeles Department of Water & Power Board of Commissioners. A graduate of the University of Iowa, Carolyn was a HUD Urban Studies Fellow in the Graduate Program in Urban & Regional Planning at Iowa.

Carolyn was National Board Chair of the American Association of Blacks in Energy (AABE) from 2007-2009 and served as Environmental Committee Chair for the National Petrochemical and Refining Association (now American Fuels & Petrochemical Manufacturers). She is Past President of the Dean's Advisory Board for the College of Liberal Arts & Sciences (CLAS) at the University of Iowa and recently served as the alumni representative on the search committee to replace the Dean of that college. She also serves as Treasurer of the Alliance to Save Energy, a consortium that, among other initiatives, is attempting to double US energy productivity by 2030. A member of the Executive Leadership Council, Carolyn co-chaired its 2016 Women's Leadership Forum. She has served on the US EPA's Clean Air Act Advisory Council, its National Advisory Council for Environmental Policy and Technology (NACEPT) and the National Advisory Council for matters related to the North American Commission on Environmental Cooperation under the North American Free Trade Agreement (NAFTA). Closer to home, Carolyn is a graduate of the Leadership Philadelphia Executive Program. She co-chaired the Philadelphia Arts & Business Council Strategic Planning Committee from 2002-2008 and serves on the Executive Committee of the Urban Affairs Coalition, where she co-chairs the Personnel Committee. She also is a member of the

Chapter of the Philadelphia Episcopal Cathedral. Most Sundays she can be found singing in the choir at St. Martin-in-the-Fields Episcopal Church, where she also occasionally plays the recorder.

Carolyn lives in Bryn Mawr, Pennsylvania, with her husband of 36 years, Michael Blakeney, an interior designer.

Living My Values Through The Energy Value Chain

by Telisa Toliver

"Where the is no struggle, there is no strength."

—Oprah Winfrey

I have never liked the term "overachiever" because it is related to the expectations of others. High expectations were set for me early on and were the foundation for my upbringing.

As I listened to my large extended family—my grandparents, my aunts and uncles, and my parents—tell the stories about how they struggled but excelled in everything they set out to do, regardless of the odds, I felt it my duty to follow the same path. When they each described their own journey, their stories weren't peppered with angst, but with pride of how they overcame the obstacles of poverty and discrimination, what it took, and what they expected of those who came after them.

While my grandparents had limited formal education, they never lacked intelligence. My parents were both HBCU college professors and smart as hell. My mother kept us in stealth, continuous learning mode. My brothers and I look back on our childhood and laugh because it took us a while to figure out that almost all of

the games we played were actually educational tools. We spun the wheel for geography, spelling, grammar, and math, so focused on the competition that we didn't realize how much we were learning.

We started our education on a college campus, a laboratory school with educators from Langston University. I understand and am grateful that I was genetically inclined to be an intellect, but we were a family that never forgot where we came from. I was raised to couple that intellect with plain common sense. I vividly recall my awareness of the concept of an "educated fool," used for those who, in spite of being book smart, did not have a sense of self. That was the person you never wanted to be.

My parents divorced when I was in the sixth grade. I think my brothers and I still carry emotional scars from their divorce as we have grown older, whether we want to admit it or not. After the divorce, we moved to the small Oklahoma town where my mother had grown up. Even though we'd visited my grandmother and our extended family there every summer, it still seemed like a strange place when we got there to live for good.

My family was well known in town all the way back to my great, great grandfather. Despite our family's legacy of excellence and pride, I always felt the underlying doubt that was subtly and sometimes not so subtly directed at me from teachers, people in the community, and sometimes my friends and schoolmates. There were plenty of folks in this town who worked in the oil and gas fields, but very few went to college. I always felt someone was trying to lower my expectations for my future.

That covert and sometimes overt communication, coupled with my own desire to succeed, fueled my ambition. This small town, like everything, was good and bad. It was home. It was overwhelmingly

Caucasian. It was the place where I developed lifelong friendships, but where I knew the perspectives and opportunities were limited and small.

Although the racism that was fully baked into the fabric of the community when my mother had grown up there was more subtle, it still reared its ugly head, time after time.

I Knew At Some Point I Would Leave

I took my first chance to leave after high school when I enrolled at Tuskegee University, where my father worked.

Even though I had started out in the HBCU arena as a child; was raised to be a proud black woman from a proud black family; and I knew exactly who I was as an 18-year-old college freshman, I had a significant culture shock when I arrived at Tuskegee University.

That may sound strange, but I was unique amongst my peers because I'd spent my formative years in a predominately white town where I was exposed to "their" music, dialect, education, and culture.

When I got to Tuskegee, an HBCU with a strong history of black excellence, I assumed most of the students who came from large cities around the country would be smarter than me. I quickly learned that wasn't really the case. I also figured out that my time there would be a fit of contradiction, as I was peppered with comments such as:

"You talk like a white person."

"You know things only white people know."

These statements came from my black peers, and so I never really felt a part of the larger student body. So, I just got my degree *with honors* as quickly as I could, and kept it moving!

Ironically, today I am the liaison between my company and Tuskegee, having supported significant funds for student scholarships and engineering school facilities. While my time there wasn't the best experience, it did provide significant learning and growth in terms of being who you are without regard to others' perspectives of you.

Tuskegee is a great university, and I am a proud alumnus!

As a college student, I knew I had the blessing and the curse of being equally led by my left and right brain. Back then, feeling that my creative side and my linear thinking tended to battle each other, I used to think I had to pick a side. My plan was to go to college, get a business degree, and become a creative in the entertainment business in Los Angeles or New York.

Even though my mother was highly educated, I watched her work multiple jobs to take care of all of our needs and most of our wants for me and my three brothers. I always knew that while money isn't everything, at times it can be, especially if you don't have it. The concept of being a starving musician, actor, or anything was a nonstarter.

I Never Sought To Be In The Oil And Gas Business

During my sophomore year in college, I interviewed with several companies. All of the recruiters were white men, with the exception of the executive from Gulf Oil.

He worked in a small refinery off the East coast.

"How many black employees are at the refinery?" I asked.

He looked at me, and without blinking, said, "You are looking at him."

Looking back, I now understand the position that one black employee was in. The internship in question (which I was offered)

was not at the refinery, but Gulf had to look for that one black employee who was willing to come down South and recruit at an HBCU.

Even today I empathize with being the first, the only, the double-counted minority woman. Another blessing and a curse.

I had the privilege of working for Gulf for two summers in Oklahoma. I wasn't sure how I would stack up against the other interns, so I went in with a vengeance to assure the company and myself that I could compete.

"Slow down," my manager told me one day, "or we're going to run out of things for you to do."

When I graduated from Tuskegee, I received several employment offers from a few different industries. At the end of the day, the oil and gas companies offered me the most money and that informed my choice.

This was the beginning of knowing what ranked high in my value system.

My first job out of college required me to move to Houston, Texas, where I knew no one. My older brother drove me there in a truck with all my belongings: a small 12-inch television, a mattress set, and a bean bag.

"Please, please, please don't just drop me off," I begged him. He stayed an extra day. I watched him drive off, and as soon as I could no longer see the truck, I cried like a baby. Here I was in this huge city without friends, family, or a car!

I dug right into my new Associate Analyst position. I reviewed proposals to drill and came to understand what regulatory treatment (in terms of expected revenue) the discovery or production was expected to receive. After a little over a year on the job, I

learned my company was being bought out by another oil company, Chevron.

I had no idea what that really meant until a representative from Chevron interviewed me and advised me that only engineers did the work that I was doing.

"We can offer you a different position in California," he said matter-of-factly.

Without hesitation, I said, "I really can't afford to move to California." Before he could say anything else, I said, "Well, since I'm doing the job, you can pay me what you are paying the engineers."

Although that logic did not work—I felt it was worth a try. I declined the offer to move to California, though I did receive what I thought was a generous severance payment. I promptly started interviewing for other jobs in Houston.

I landed at Texaco, where my career really started. My first job at Texaco was as a regulatory and contracts analyst in the natural gas division. This position helped me to understand the commercial part of the business. I was learning a lot about the industry, but I also started noticing that most of my colleagues in the department had been there for a long time.

I very quickly deduced that this was a place where you either got out quickly or stayed in forever.

I wasn't about to be one of those who lingered, so I kept my eyes open for other opportunities. I noticed a group of employees in natural gas sales who traveled and interacted with customers. These people were really driving the business. Best of all, these guys looked like they were having fun.

My ambition kicked in and I got busy working hard to land a sales position. Once I succeeded, that's really where my love of building relationships and business development began.

When I say, "these guys," I really mean *these guys*. Women in supervisory positions were rare, and they certainly did not look like me. However, I latched onto the one or two women supervisors for their guidance. I worked hard for them and they supported me.

One thing I knew early in my career is that the respect and bond created by working hard and accomplishing goals together is common, whether male or female.

"You Don't Know What You Don't Know"

This adage never got in my way. I am usually oblivious to the obstacles that are in front of me. It never dawned on me that I would not be successful. This attitude was perceived as confidence by some, but arrogance by others. Regardless of the external perception, I always backed it up with my performance.

After about four years in the natural gas group, an opportunity was presented to me. Remember when I said I couldn't move to California? Texaco moved me to Los Angeles, and it was one of the best career decisions I made. No one else was willing to relocate for a variety of reasons, including family, the cost of living on the West coast, and so on. I had the luxury of being free and single. I had absolutely no idea what I was in for.

Although I was again terrified to go to a city where I had no friends or family, I went anyway. The first couple of years were a struggle—I always felt like I was robbing Peter to pay Paul—but my job provided unforeseen growth and development. Because I was the only one from my department in the LA location, I had more responsibility, more exposure to leadership, and more accountability than my peers back in Houston.

As my career path at Texaco became more and more solid, I noticed what felt like a widening distance between myself and other

black employees, including those who'd joined the company when I did and others who had been there a long time. Once again, I heard unsolicited commentary:

"You know how to talk to them."

"I would never work the hours you work."

"They are never going to treat you fair, so what's the point?"

These statements took me back to my college days. I was torn and perplexed, but it wasn't my style to slow down. Again, I kept it moving.

Of course some black employees were supportive, but not many were in leadership positions, so I was on my own in navigating my career.

The oil and gas industry was not different—no better, no worse—from other industries in terms of the lack of diversity throughout the organization. And it was certainly more pronounced at the leadership level.

I was an employee at Texaco during the mid-1990s when the infamous "Jelly Bean Race Bias Settlement" occurred, after executives were caught on tape deriding and belittling black employees. The race bias suit ultimately settled for $176 million.

As a result, the atmosphere between colleagues and friends was awkward, to say the least. It was a horrible time on all sides—whether white or black—with feelings of resentment, embarrassment, and anger.

During that time, I attended a regulatory hearing. When a commissioner saw that I worked for Texaco, he asked *on the record*, "How are you doing?"

At another time, I was on vacation and was sitting across from an African American member of Congress. "And you are still there after what is happening?"

The undercurrent of her question was a judgment as though I were betraying my race.

"While these are troubling times," I responded, "my industry is no worse than others."

She looked at me with disdain.

It was crazy. I had good friends at the company—white and black. I felt like I had to defend, even though I was deeply embarrassed about what was happening. Everyone seemed to ignore the fact that when the cameras, news reports, and jokes ended, we all had to go back to work *together* and achieve the goals of the company.

When the suit was settled, the subsequent progression of African Americans at Texaco was discounted as a product of the lawsuit, rather than the performance of the individuals. I don't know that the company image ever fully recovered from that incident.

Big companies love to reorganize; it makes new leaders think they are demonstrating a path to better performance, so after about six years of increasing success in Los Angeles, I reluctantly returned to Houston. I was a bit lost at that time, wondering what my next steps would be.

I met a senior executive at Texaco, a white man, who was an advocate for me and later became such a dear friend, I consider him family.

At the time, he told me, "If you don't do something else and move to another segment of the business, people will think that is all you can do."

After interviewing with him for a position which would turn out to be his commercial advisor, his feedback was, "Your responses had the exact amount of detail needed for the questions I asked."

That's when I learned the value of communicating only what is needed to inform and make decisions—and nothing more.

This job provided the beginning of my understanding of the global nature of the oil and gas business. We were working on projects in Russia, Venezuela, Bangladesh, Nigeria, Angola, and the Philippines. The world was beginning to open up to me, and I wanted to experience it.

At a time when we were considering an exploration investment, I took a trip to Colombia. We rode in an armored car accompanied by men on motorcycles with guns. We then boarded a small plane, headed for the jungle. After we landed, we made our way toward the exploration acreage. We were notified that a storm was coming.

"We can't go now," the pilot said as we re-boarded the plane. "Due to the storm, we may not be able to fly high enough to keep us out of the range of machine gun fire from the ground!"

I couldn't help but think, *What in the world is a small-town girl from Oklahoma doing here?*

Of course we made it out alive, but I will always appreciate the experience. It was a real snapshot of what it takes to supply increasing demands for energy to a world full of countries that are seeking to improve their standard of living.

During this time, the work was grueling. I was exerting an extraordinary effort to cultivate others' confidence in my abilities. Simultaneously, I was developing strong professional relationships with two female colleagues who continued to support me throughout my career.

I was really feeling my stride at Texaco. I was invited to the leadership development summit, which was an indication that I was on the right path. Two or three leaders whom I respected were advocating for my success, and I was receiving promotions at an accelerated pace.

Then abruptly, an announcement came: Chevron and Texaco were merging. My career was coming full circle. I worked for Gulf, and Chevron bought Gulf; I left and went to Texaco, then Chevron bought Texaco.

At the time of the merger, I knew that my part of the business was not aligned with Chevron's asset base. I quickly started looking for what my next steps could be. An answer came while I was in a business meeting in Louisiana. One of the women I had previously worked with called to ask if I was interested in working on the merger team in San Francisco, which was Chevron's headquarters at the time.

The catch? If the merger didn't go through, I would not have a job.

I offered to fly out on the next plane heading West! I knew it was a risk worth taking, as this would allow me to get familiar with some of the Chevron executives. At the same time, they would get to know me and what I could contribute. I wanted to see what kind of company was being developed for the future.

Turns out, this was a really good decision. I was called on by a female colleague; we had worked together before and she was aware of my work ethic and what I could contribute, so she advocated on my behalf.

After the merger closed, I was offered a job on the leadership team at Chevron's refinery in Mississippi. Operating plants and field production areas are where the rubber meets the road!

While I was reluctant at first since I was the only former Texaco person at the refinery, it was a great experience with great people who take pride in what they do every day, around the clock. The best leaders are those who know what it takes on the ground and in the office, and they respect the roles that each play. I always

encourage employees to lean in to those opportunities that seem out of their wheelhouse. You grow as a leader as you learn and broaden your experiences.

After being in Mississippi for two years, that same colleague who offered me the position on the merger team now offered me a position in Corporate Strategic Planning back in California. In addition, the senior executive at Texaco to whom I was an advisor was promoted to a C-suite position in the merged company.

This is one of the best positions I ever landed. While some folks have a bit of disdain for "corporate," being in a corporate assignment allowed me to see how decisions are made at the most senior levels of the company. I saw how to communicate effectively in very stressful and time-constrained environments. I learned how to develop relationships at all levels of the organization. I watched the behaviors and styles of leaders who had tremendous responsibilities and accountability. I certainly learned that the one with the bigger title is not always the one in charge. I saw how excellent leaders stand out and drive the business without hesitation. I watched how they considered the implications to our employees, our company performance, and reputation with each decision.

Exposure works both ways, I like to say, as you can shine as well as get burned. Exposure is worth the risk.

After three years in corporate, I moved back to Houston as a VP of one of Chevron's smaller business units. I had accountability for power development in the Americas, the Middle East, Europe, and Africa.

Again, the theme here is that a former female executive hired me for that position, and for the next one.

I believe that additional responsibilities come with being a leader who happens to be a minority in a large corporation. Not

all of my African American colleagues agree. I have been told this belief is a burden, and that because I have chosen to put my money where my mouth is, I may likely have harmed myself in the long run. I don't believe that. Because of the way I was raised, because of those who blazed a path for me, because of those who supported me, I believe I have a moral obligation to help others who are trying to be leaders in our industry. I take my very limited discretionary time to mentor women and men—majority and minority alike. But I make an extra effort to mentor those African American employees who look to me for guidance.

At the beginning of my career, very few minority leaders worked in oil and gas. Naturally, a bit of doubt always lingered about whether I could succeed, because I didn't see anyone who looked like me. I'm sure other women and other minorities have felt the same. I am amazed at how many young black employees whom I have never met, find me and ask for advice on: how to navigate their careers; how to deal with a difficult situation at work; or whether it's all worth the effort. I have and continue to receive distress calls from employees who are at their wits' end and contemplating whether to stay or to go, mostly because of perceived inequities or lack of opportunities.

I never give them the answer or tell them what to do, but I ask many questions to really get to the issue at hand. It is not always them; sometimes it is us. I have created a reputation that is a blessing and a curse, as it is hard to say no. People believe what they see, and visible role models are extremely important. If I met an African American or a female whom I watched over time and I respected, which is the first step, I would unabashedly seek their advice. I was never turned down.

In this abbreviated form, I have shared my journey over the last 30 years, illustrating woven and intertwined patterns of hard work, teamwork, trust, advocacy, friendships, and risk-taking. One of the most important experiences I left to the end are the incredible mentorships I received from African American women and men who are pioneers in the energy industry and who saw something in me that made them want to support me with guidance and love over the years. I can be impulsive when treated unfairly, and these men and women have guided me over time to keep my eyes on the long-term prize of leadership and success.

I certainly don't want to leave the impression that there were not or currently are not strong African American leaders in the energy industry. Giants and standouts exist in our industry. While at Chevron, I met Warner Williams. He was the highest-ranking African American in operations at Chevron and by all rights had reached a level where he didn't really need to do anything for anyone. But I have never seen a stronger champion for the development of African American and women employees. I have the highest regard for him as a leader, mentor, and friend.

I always tell employees that you cannot effect change unless you are in the room when key decisions are made.

Warner was in the room!

About 10 years ago, Warner invited me to attend a conference for AABE, the American Association of Blacks in Energy. I was not familiar with the organization, but when I arrived, I was in awe. It was love at first sight!

Where have you been all my career?

Suddenly, I was amongst about 500 African American energy professionals from around the country, including CEOs and C-suite

executives from oil and gas, utilities, and federal and state government agencies. All energy professionals, all subject matter experts, all leaders, and all African American.

It is hard to explain the sheer joy, the pride, and the impact this organization has had on me. Knowing that it is possible to reach the highest levels of leadership in this industry gave me hope—for myself and for the future of our industry. I have developed mutually beneficial friendships across the country that have expanded my presence and sphere of influence in ways that have surprised me. I am now proud to say that I am the current Chairman of the Board of AABE, following in the footsteps of great leaders for whom I remain in awe.

For those of you who are seeking lessons learned, I offer the following:

- Leadership is not for the faint of heart. It costs to be the boss. The buck stops with you. If you are not willing to do what it takes, don't seek it. It's hard, it's risky, and it doesn't get easier over time.

- Don't wait for someone who looks like you to help you or mentor you. Find a colleague or leader whom you respect, who knows the business, who understands your strengths and gaps, and is willing to support your goals.

- Taking calculated risks is the most rewarding thing you can do. Demonstrate your openness to new challenges. Say yes to jobs that may seem out of character. Believe that there is something to learn from every opportunity. Conquer fear by diving in head first!

- Stay keenly alert with what is happening in your company and your industry. Make sure you know where the puck is going and be ahead of the curve. Read the tea leaves and don't get left behind.

- More importantly: Relationships Matter! Relationships Matter! Relationships Matter!

- And most importantly: *Know* and *live* your values, be true to who you are, and trust your instincts when doubt surfaces about what you are capable of.

While my career journey has been positive, I don't want to portray a glossed-over or overly rosy picture. The value tradeoffs we all make during a career are complex. There have been good and bad times. I have developed lifelong friendships with several colleagues. I have seen, faced, and challenged egregious discrimination of women and minorities. I have had extremely incredible bosses and extremely horrible bosses, but learned lifelong lessons from both. I have had to fight the urge to listen to those who tried to plant seeds of doubt about my ability to successfully navigate the professional and political paths in corporate America. I have sacrificed relationships and time with my loved ones, family, and friends. I have moved no less than nine or ten times over my career. I have a reputation of working hard and playing hard. I earned that reputation!

When I really reflect, deep down I feel I have led a double life. Outsiders consider me incredibly successful, and while I know I am living a great life compared to most, I also truly know I should have achieved more and probably could have if I had followed my instincts better, owned my value from beginning to end, left when I should have, or stayed when appropriate. On the other hand, I

recall an old saying about those of us who claim hunger with a loaf of bread under our arm. All this brings me back to the proper level of gratefulness and thanksgiving for what I have and what I have accomplished.

As such, I believe in the global benefits of the energy industry and the opportunities they present. I have travelled all over the globe, seeing firsthand how access to energy resources results in an improved standard of living for communities previously steeped in poverty.

In addition, I see the recognition of diversity and inclusion in all parts of our business. I have been a longtime advocate in explaining to African Americans the benefits and opportunities in our industry. How they can have long, successful careers, send their kids to college, and retire with peace of mind. I know that my family and friends tire of my soapbox, but I have convinced many, including a couple of my family members, to join this industry.

However, I also tell those whom I mentor, and all who will listen, to prepare for the future. To make sure they set themselves up to be valuable to the company they work for, but also valuable *outside* of the company they work for. Never get complacent or too comfortable. Industries go through ups and downs, and we must take advantage of the highs, and be prepared for the lows.

Life is certainly a cycle of transitions. While I am still working, a time will come soon when either I or the company will say it is time to go. Time to do something different. I had the luxury of starting in this industry as a college intern, so I am still young enough to do something different: build my own business in this industry or another with the latitude to create and shape the culture, or do nothing... for a while.

But as my friend and colleague Paula Glover says, "Trust and Believe" it's not over!

Biography Telisa Toliver

Telisa Toliver serves as General Manager for Chevron Pipeline and Power. Chevron's Pipeline and Power business unit provides technical, commercial, operational, and energy management support services globally to Chevron's Upstream and Downstream & Chemicals businesses. Its owned and operated pipeline assets span 3,000 miles, supporting Chevron's operations across seven US states and transporting more than 1.2 million barrels a day. Its power function manages or operates 950 megawatts of natural-gas-fired, steam, and renewable power assets. And its energy management services evaluate energy use and find solutions to improve operational efficiency, reduce cost, and address Chevron's critical energy challenges across the globe.

Telisa was named to her current position in 2018 and directs commercial and business development activities associated with owned and operated pipeline and power assets. Telisa also oversees the management of Chevron Pipeline and Power's interests in all non-operated joint ventures and is accountable for acquisitions and divestitures. She leads the development and implementation of the Pipeline Risk Management strategy for delivery of pipeline operations, engineering, and commercial services across Chevron's global enterprise, including organizational capability. Telisa is also responsible for developing and implementing power market strategies that will enhance Chevron's operations and new investments.

Telisa currently serves as the Chair of the Board of the American Association of Blacks in Energy and serves on the Board of the World Affairs Council of Houston. She is also a member of the Executive Leadership Council.

Serendipity, Proximity, and Grace

by Rose McKinney-James

A little over 65 years ago, a child was born to another child, a girl just past her 15th birthday. She, the mother—*my* mother— was vivacious, gifted, and brilliant beyond her years. She was precocious, free-spirited, and socially active. Those around her witnessed the promise of her gifts of music and art.

Her "situation" brought great strain, embarrassment, and conflict into an otherwise tight-knit family, a family still in recovery from issues related to the stress of forced migration and the racial strife of the times. The strain extended beyond her parents to her grandmother, as the three generations shared an important bond, and she represented a stunningly divisive aberration.

My mother generated a significant dilemma, a conundrum of huge proportions, that weighed heavily on her parents' hearts and minds. Her parents were extraordinary and at the same time ordinary, simple, hard-working, middle-class Americans: her mother was a teacher; her father was a Pullman Porter; and her grandmother was a preacher. They migrated from the Deep South to the industrial Midwest seeking greater economic opportunity, stability, and personal freedom, leaving sharecropping and coal mining in

the rearview mirror.

The difficult question was: Would this actually be the beginning of a fourth generation or would fate intervene?

The child born out of wedlock was hastily sent to foster care, pending adoption. That child could have disappeared into the labyrinth of the challenging world in search of "forever families," but was lovingly retrieved by the Pullman Porter, simply because she was, in his words, his "flesh and blood."

Grateful for the rescue and the comfort of a loving home, the child sought to please, was obedient, and excelled academically. She emerged as a gifted athlete and musician.

That child was infused with their wish that she be resilient and that she live a life with meaning and purpose...

As I reflect upon my beginnings in this world, my heart is full with gratitude for this single gesture. While I benefit from the strength, talent, and courage of the three African American women who shaped my life, it was my grandfather who instilled in me the fortitude required to stand my ground in the face of adversity. My story began not with humble beginnings, but instead I was raised by those who were themselves humble. I remain grateful for the rescue and the comfort of a loving home. I mention this because the true details of this predicament only became clear to me as an adult, as a tightly held secret that unraveled slowly and without preparation.

It's hard to know exactly what aspects of our past actually fuel our present.

I'm a survivor in more ways than one.

In my early 20s, I survived what may have been the first terrorist attack on US soil. The Hanafi Siege took place in March of 1977 in Washington, DC and created a survivor, not a victim. Over three days, in three buildings, dozens of unsuspecting people were

terrorized and held hostage while the DC government leaders, law enforcement, and the Pakistani Ambassador negotiated our release. While it was never completely clear to me what precipitated the attack, I played a small role in bringing the nightmare to an end.

After stumbling into the sight of a receptionist being held at gunpoint, I slipped into the Office of the Council Secretary. Based on what I witnessed, I convinced the Office to allow me to contact the mayor and serve as a conduit between the Office of the Council and the mayor. I then kept a telephone line open that allowed critical communications between the mayor and law enforcement. After three days of uncertainty and terror, I was rescued by SWAT.

I survived.

The voice of a survivor is powerful. It speaks truth through shock, fear, and pain with a clarity that is focused and crystal clear. It also presents a unique opportunity to begin anew and propel oneself forward with a refreshed sense of purpose.

I have always been drawn to service and am driven by the oft-quoted goal of "making a difference." Early in my career, I lacked the precision of experience to craft a specific direction or vision to act on that desire. Prior to the life-changing experience of the Siege, I'd always relied on the single constant in my life: I turned to the incredible love and support provided by my maternal grandparents, keeping a steadfast awareness that, as an infant, I was literally saved from a life of uncertainty and instead launched into a life of continuous exploration and serendipity. They provided the foundation. I'll be forever grateful for their unconditional love, support, and guidance. It gave me the strength to search for an opportunity to serve.

Learning from a generation once removed shaped my lens for approaching life. My grandparents held the same core values as

many of their peers. And like many people of a certain age in the African American community, education was always emphasized as the key to the future. So, I learned to focus on the present with an eye to my future. It was exciting and terrifying, and I have frequently experienced both ends of that spectrum. All at once, I was their future. And now, upon reflection, I have the benefit of having lived life through their past. This, I hope, will be my legacy.

Music

Music paved a path forward in my life that was not planned, but anticipated. It included many twists and turns emblazoned with serendipity. My gift for music was developed early. As a toddler, I sang in Sunday school, and at seven, I was literally pulled from a group of second graders in a music classroom and inserted into the elementary school's glee club. I was told my voice was a gift that required my full attention and commitment. Suddenly, I was jolted from innocent anonymity to awkward popularity.

Yet, I could not ignore the power and influence of music: it empowered me, opened many doors, and offered an opportunity to distinguish me from my peers. I enjoyed the related travel, the camaraderie, and the general beauty that music brought into the lives of others. Growing up in Detroit in the shadow of Motown increased the pressure to pursue a career and become a performer like my mother.

However, I did not enjoy the attention. Frankly, I just didn't think I had what it took to succeed in the business. I lacked the emotional maturity to appreciate or bask in the compliments I received. My vocal skills evolved and over time I was featured in numerous church and school choir performances, including solo performances in Carnegie Hall and ultimately, Madison Square

Garden. I was aware of a strong expectation that I would follow in the steps of my now-famous mother, whose singing talent had blossomed into an acclaimed professional career. But my choice was not to follow that path.

My voice served me well and established a lifelong love and appreciation of and for music and the arts. Very importantly, it provided a critical bridge between my limited family resources and my future. Opportunity manifested in a full scholarship to a small Midwestern liberal arts college. Olivet College is a private institution nestled in a small city in southeastern Michigan. My vocal music scholarship was subsequently modified to include athletic and academic companions.

When I graduated from Olivet as Class President, I had achieved letters in basketball, tennis, and volleyball, and three seasons as an (extremely pitiful) cheerleader. It was, however, my voice that helped me reach a place where my destiny could mature. While I fulfilled my obligation as a performer, I came to resent rather than enjoy the experience.

As those around me still envisioned my future steeped in music, I was drawn instead to defy those preconceived notions and chose instead to challenge the status quo.

In the early 1970s, as presidential candidate George McGovern gained popularity with college students, I literally stumbled into politics and ultimately found a calling in advocacy and public service. McGovern's emphasis on inclusion and diversity created a unique vehicle to enhance my status as a politically active college student and leverage the visibility gained through my singing.

Upon reflection, it's clear the seeds of this passage had been sown over many years: a summer internship with the City of Detroit; an

opportunity to join the Michigan delegation in Miami for the 1972 Democratic National Convention; a failed run for a Congressional seat at 19. This collection of experiences supported my decision to segue from music to political science.

In fact, during my tenure at Olivet, I had one beloved political science professor who tested, challenged, and worked my nerves daily! He was determined to demonstrate my capacity to engage in substantive debates and advance important civic and community issues. He pushed me to sharpen my debating and writing skills. He suggested that I identify tangible opportunities to engage in the political process. I was therefore encouraged to pursue electoral politics at an early age.

This was not a stretch for me: As a girl, I had marveled at my grandmother's strength and leadership as she represented her neighbors in an historic effort to secure equal housing in the segregated 8 Mile Road area of Detroit. She was revered by her neighbors and the members of the Detroit City Council and the Housing Commission. She had earned their respect.

As my graduation from Olivet approached, I knew I was arriving at a point in my life where I coveted that respect. I was compelled to seize the opportunity to be intentional. Although it's difficult to explain the desire to be seen as someone worthy of conversation, opinion, and intellect—beyond the gifts of music—that became and continues to be an essential aspect of my personal development.

As I pondered my future, I realized that everyone I respected was engaged in the law. As a result, following in the footsteps of my trailblazing grandmother, I made a pivotal decision to attend law school. My political science professor specifically curated a unique opportunity for me to attend not just any law school but an institution dedicated to training advocates. The Antioch School of Law in

Washington, DC was designed to achieve precisely that goal.

Adjusting my academic curricula to include pre-law coursework jeopardized multiple scholarships, but I'd found a different inner voice and made securing a slot at Antioch my goal. My experiences, collectively and individually, while not necessarily sequential and not at all connected, were indeed founded in pure serendipity. Against all odds, I secured that slot and moved from Michigan to Washington, DC.

Career

Thereafter, a series of unplanned opportunities forced me once again to rely on the combination of my liberal arts education and—thanks to the influence of my great grandmother—an abundance of common sense and basic perseverance to perform numerous complex tasks for the first time without specialized training, experience, supervision, or professional guidance.

In my first year of law school, a tennis partner helped me secure an internship with the US Department of Labor Women's Bureau. This exposure to the women leading the Bureau helped to establish an appreciation for the significant contributions that women were making all over the country.

During my second year, through a mandatory internship program, I had the thrill of joining the staff of Shirley Chisholm, the remarkable Congresswoman representing New York's 12th District, who had been the first black woman elected to the US Congress in 1968.

Two years before I began working in her office, I took a bold step—one of many I've taken out of a compelling confidence and necessity to do the right thing—when I was a delegate for George McGovern at the Democratic National Convention.

I knew I was part of an historic moment, so I asked the caucus leadership for permission to cast the first ballot for Mrs. Chisholm. I received permission, and although we knew she was not poised to acquire sufficient votes to actually secure the nomination, this act was the first connection in a bridge from that moment in history to my future vote for President Barack Obama.

As a young woman, my world exploded with horizon-bursting exposure to the legislative process. Mrs. Chisholm's office was awash with smart, confident, and experienced women. I began as a law school intern and returned after graduation as a staff assistant. While there, I gained a deep love and respect for her and for the legislative process. The women in her office embraced, nurtured, and regaled me with warmth, wisdom, and guidance.

My experience also directly exposed me to a rigid, racially divided, and biased environment of enormous proportions. For many months, while I felt valued by the Congresswoman and her staff, I felt invisible in the halls of Congress. It was one of the most challenging—albeit memorable and meaningful—times of my life. The exposure that she provided to me enhanced my confidence and my marketability. Good thing, too, as law school had been ridiculously taxing and hard, and I feared failure.

I seriously considered an early departure, but once again I was rescued. My Supervising Attorney and Civil Procedure Professor, Sharon Pratt Dixon, insisted that I carefully weigh my options. Her intervention, combined with my desperate fear of disappointing my grandparents, gave me the strength to persevere. I survived the fear, embraced the challenge, and graduated.

Drawn towards a more stable, racially balanced, and less hectic life than that of the Hill, I left that familiar space to work with the

DC City Council. I was recommended for a position by Sharon Pratt Dixon and was subsequently recruited and offered an opportunity to work for the Council Chair. Ironically, the post of Council Chair was held by her husband, Arrington Dixon, an energetic, dedicated public servant determined to improve the quality of life for his constituents.

He embraced my legislative experience and set me on a course that culminated in a work ethic designed to blend my legal training with the creation of legislative initiatives and community-based programs. Although I often regretted the decision to leave the Hill, the experience serving the City Council allowed me to flourish and hone my skills in public service while engaging in a broad range of local government issues. I was energized and inspired.

It was here, in the midst of this remarkable opportunity that offered me so much upside and potential, when the devastating interruption of the Siege occurred.

Life in DC after the Siege was complicated and uncomfortable, but I was still willing to experiment, so I left the City Council to try my hand with an NGO (non-governmental organization) dedicated to working with community-based groups requiring technical support.

During my tenure with the National Economic Development Law Center, surrounded by seasoned, dedicated lawyers, I found a renewed sense of purpose. I was given the opportunity to travel the country and meet incredibly gifted community leaders. I worked in Appalachia, Wisconsin, and Nevada. I worked with leaders who were creative, resourceful, and inspiring.

Things were going very well, but memories of the Siege continued to haunt me. I recognized that my emotional well-being

required that I put some distance between myself and the tragic events in DC, so when serendipity intervened, I accepted a one-year consulting opportunity in Nevada.

The decision to move West was hasty and by most accounts ill-advised, but appealed to that sense of adventure and wanderlust, a trait from my well-traveled mother. Moving to Las Vegas for a year in the early 1980s was largely a lark. But the decision to make that trip changed my life.

I was assigned to Operation Life, a community-based organization focused on improving the quality of life for women and children in historic West Las Vegas. It was an organization founded by a group of African American mothers. Most were former second- and third-generation welfare mothers. They too were survivors: women who had to struggle every day to make a way for themselves and their families. They were black women who faced enormous economic and social challenges. They were determined to work together to draw attention to the plight of black families and identify the resources required to lift them up from poverty into the mainstream of the American Dream.

Led by Ruby Duncan, the women of Operation Life drew national attention to the movement to address poverty by staging a sit-in on the Las Vegas Strip. Their courage served as a true beacon to those watching.

When I began working with them, I sensed that they viewed me as a distrusted outsider, and those first few weeks were extremely tense. I took a leap of faith and accepted the fact that I had one year to design and build a support system to manage both program and grant accountability where none had previously existed. I just dug in and put my heart into turning things around.

With the support of representatives from the City of Las Vegas and an engaged Board of Directors of Operation Life, we turned around a potentially devastating situation and averted the loss of significant federal funding.

During the year I worked with them, I worked hard to earn their trust and ultimately became their trusted advisor and friend. And in turn, they taught me the importance of self-induced empowerment. Working with Operation Life was my first real success, and I was incredibly satisfied. My long-term view at the time led me to believe that my career would be focused on community, economic development with an emphasis on development, and finance.

I believed I had found my niche.

City Of Las Vegas And Family

After completing my assignment with Operation Life, I had to make a critical decision. I needed to determine whether to remain in Nevada or return to DC. As I explored my options, my life changed dramatically. My beloved grandmother suffered a debilitating heart attack in Detroit, requiring me to immediately return to support and care for her. During her subsequent recovery and convalescence, a return visit to Las Vegas to settle outstanding obligations resulted in a chance re-introduction during a colleague's birthday celebration to an intriguing stranger. He was tall and confident, initially displaying a curiously attractive aloofness. We'd been introduced previously, but he just *looked* married and unavailable. That night he was full of conversation and humor, sporting an awesome mustache. The conversation continued as we shared a bit of social awkwardness. Over time he provided me the love, support, and safe place necessary to continue my journey. Now we share two

remarkable sons and a 34-year journey together.

However, back in the moment of planning to return to Detroit, word spread quickly that I was leaving Las Vegas and that serendipity popped up again.

I was advised that the City Manager's Office had been impressed with my work with Operation Life. I decided to pursue a series of meetings, calls, and interviews, and I was ultimately offered an opportunity to work with the City of Las Vegas. With my grandmother stable and recovering well, I happily transitioned back to local government, knowing that I'd been provided a path to revisit the experience gained in Washington, DC.

I decided to remain in Las Vegas because *he* was there. Holding a position within the Finance Department, he continued to quietly provide support and offer stability.

In my role at the City Manager's Office, I received my formal training in economic development, finance, and project development. I was given the chance to leverage my previous experience by working with small businesses looking to secure capital for growth. My foundation in administration, community, and economic development allowed me to work my way through the ranks of local government, starting as an analyst, then partnering with the US Small Business Association (SBA) to become a small business advocate, and finally to become Chief of Staff to the City Manager.

I was gaining confidence in my work and became a trusted and critical resource to the City Manager. He was smart, ambitious, and a strong leader. He encouraged me to take on projects and assignments that would stretch me intellectually and professionally.

As a black woman, I faced significant pushback from many of his direct reports. The predominantly white male leadership was

typical for the mid-1980s. Most respected the chain of command. Many had military training and respected the role of a Chief of Staff. However, a few made every effort to ignore, frustrate, and disrespect the role. These individuals were sexist, racist, and in many cases, intellectually inferior. The arrogance and hubris they displayed has become a frequent and unwanted companion in my professional life. Chipping away at the resentment and finding a way to distance and dismiss the most resistant among them made for a challenging but gratifying experience. While they shook my confidence, they also forced me to dig deep and rely on the courage I'd seen demonstrated by my grandparents. I refused to allow them to interfere with my ability to advance and perform my responsibilities. Instead, I stood my ground, chose to ignore those unwilling to adjust, and simply continued my work.

I survived.

In 1983, the City Manager summoned me to his office and advised that my new assignment was to to join the City's lobbying team.

"This experience will change your life," he said.

As a black woman, I had no idea at the time how accurate his assessment would actually become. When I headed north to Nevada's capital in Carson City, I became the first person of color in the history of the state to represent its largest city. Once again, I had no specific training or preparation, just a willingness to learn and the attitude and chutzpah of a straight shooter.

The years of work in community economic development and local government morphed suddenly and unexpectedly into an opportunity to revisit both my legal training and legislative experience. Representing the City of Las Vegas at the Nevada Legislature became a familiar and comfortable environment. Those years

generated invaluable and lifelong relationships that I nurtured and continue to treasure.

Nevada Public Service Commission

I'm confident the convergence of many of my strengths and experiences—exposure to the Legislature, a favorable reputation, strong relationships, and statewide visibility—combined with the desire of the incoming governor to make an historic, diverse, and unforeseen appointment to the Nevada Public Service Commission, positioned me for the next chapter of my professional life.

I was suddenly a utility regulator.

The job required me to push beyond a lack of formal regulatory preparation to demonstrate that the strength and conviction garnered from my upbringing allowed me, with the support of my distinguished colleagues, to evolve into a space where navigation of the process became manageable. Most of my colleagues had come to the job with experience, so the space they gave me to gain knowledge and experience to do the job was a wonderful gift.

Around six to eight months into my tenure, I was exposed to a regulatory filing submitted by an Israeli solar firm looking to develop projects in Nevada. This filing raised questions that, in my mind, had no obvious answers. As a vocal and inquisitive—albeit junior—regulator, I then pushed my more seasoned colleagues to also seek answers to these questions, but they were mostly focused on traditional utility policy. This appeared to create a perfect platform to avert a system otherwise designed to embrace a missed opportunity. The combination of my legal training and subsequent immersion into the principles of economic development kicked in. In a state with a single economic driver and such phenomenal

natural resources, I constantly asked, "Why are we not taking advantage of the opportunity to leverage this remarkable potential for legitimate economic diversification?"

As time passed and I evolved as a Commissioner, I continued to question the lack of a more robust plan for the development of alternative energy resources in the state. I could not understand the logic behind the lack of programs that leveraged the opportunities presented when conservation, energy efficiency, and renewable resource deployment were married into a single "net zero energy platform," meaning focusing on renewables could help reduce the reliance on fossil fuels.

I couldn't seem to reconcile the conundrum, so my common line of questioning in any public forum was inquisitive, if sometimes rhetorical. I suppose when you raise such questions in a public forum, it becomes more likely than not that you find yourself called upon to "walk the talk."

Whether I was cross-examining a Commission witness or speaking with other, more-seasoned Commissioners, I was constantly asking:

What's wrong with this picture?

How do we translate complex technological advances into a simple message of opportunity?

Why have we not witnessed any significant development or commercial deployment of renewable resources? And why are we not better prepared to pursue energy independence?

How can we improve the use of funding resources made available to us by federal and state government to truly promote the broad-based use of these resources?

How can we effectively secure and leverage private industry participation in this effort?

Why do we persist with the business-as-usual mentality?

These questions clearly had relevance beyond the borders of Nevada. In my view, these were questions that every state needed to ask.

I didn't realize at the time that the questions were, in fact, being asked and answered in other states, such as California and Massachusetts, and others were making headway. I was isolated on an island of naysayers in a small state with superior resources but with a limited voice in the national conversation. I felt we had the better resource and that we should be making headway.

Thus began my work in clean energy with a focus on solar deployment, work that was founded and grounded on a series of questions.

Reflections

I don't mean to advance this conversation past the opportunity to acknowledge the historic and life-changing nature of my appointment to the Public Service Commission, or PSC. It came without any prior discussions, just a call from the Governor's Chief of Staff requesting a meeting.

I admit that while I was curious, I couldn't imagine life beyond my work in City Hall. I did not believe I was ready to take on the responsibility and considered declining. If I got the job, I would become the first African American woman to hold the post. My husband and grandmother had intervened and insisted that I recognize it as an incredible opportunity that could not be ignored. They urged me to accept.

When I finally acquiesced, I had absolutely no clue that this single experience would eventually serve as the foundation for my

current professional life. The regulatory calendar is taxing and demanding. The rigorous structure of the dockets covering utilities, transportation, and railroad safety stretched me.

On a personal front, within weeks of the appointment, I discovered that I was finally going to expand our duet into a trio. Like many professional women facing the combination of professional and personal development, a pregnancy generates a new level of challenge. I had no idea whether I'd be able to balance the competing demands of my rigorous career and motherhood, but I chose to make the effort.

The initial five months were miserable and daunting. Fortunately my fellow Commissioners were already parents and they extended the courtesy, flexibility, and support necessary to keep me on track and engaged. As I powered through, the Chief of Staff to the governor expressed skepticism; he reluctantly signaled a willingness to allow me to continue and monitor my progress. He expressed that this was a very high-level position and it needed to have my full attention and he wasn't sure if I could manage. This was a common attitude from male professionals at the time. I ignored it.

In an effort to increase my technical knowledge, I was encouraged to participate with other Commissioners from across the country through the National Association of Regulatory Utility Commissioners, known as NARUC. Membership in NARUC represented an opportunity for professional development though national and regional meetings, workshops, and committees. Now I had a unique platform on which to exchange ideas and information. NARUC also provided a path to leadership resulting in my advancement through the executive ranks to serve as Vice President. By 1993, I was poised to take the reigns as the first African American President of NARUC.

Unfortunately reverse serendipity intervened and instead, I was summoned to serve in the Governor's cabinet.

Business & Industry

My work with the State of Nevada Department of Business & Industry began with the bittersweet excitement and prestige of being selected to lead a major state agency, in exchange for leaving an opportunity to lead a national organization in the rearview mirror. B & I is a cabinet-level state agency that focuses on supporting, promoting, and developing a strong business environment, ensuring appropriate legal operations, and protecting consumers. The reach of B & I included more than two dozen state agencies and commissions, advisory boards, committees, and a director's office.

It was simultaneously exhilarating and terrifying.

In 1995, I faced the challenge of defending the first budget for this behemoth of an agency before key legislative committees. When initially created, B & I was a monster agency. It had statewide oversight for regulating everything from banks to dairy farms, insurance, mining, housing, agriculture, and industrial relations. It was a fast-paced, invigorating, and productive ride. It offered the chance for me to work directly with business leaders and created a bridge to that community that would later become invaluable.

Blessed with an extraordinarily talented team, we secured the legislative approvals and support to fund the agency and the initiatives we outlined. Our efforts were praised by many and the fledgling agency took shape. It was gratifying, but somehow no longer satisfying work.

And like many women, I found that I had another life-changing decision to make. I was pregnant with my second child at 43...

CSTRR

Senator Harry Reid and Senator Richard Bryan brilliantly negotiated an agreement with the US Department of Energy that provided the resources and foundation for a series of pilot initiatives to assess the economic viability of using the Nevada Test Site as a vehicle for diversification through the construction and deployment of solar energy projects. The idea was initially well received, but it became abundantly clear that a successful pilot or demonstration project would require significant long-term investments and a well-executed strategic effort to support a framework for a sustainable infrastructure.

Senator Richard Bryan invited me to join the Solar Enterprise Task Force as his representative. The Task Force became the precursor to the creation of the Corporation for Solar Technology and Renewable Resources (CSTRR). The Task Force was comprised of local, state, federal, and industry representatives. It was co-chaired by Senator Bryan and former US Department of Energy (DOE) Assistant Secretary for Energy and Efficiency and Renewable Energy, Christine Ervin. That series of inquiries made during my tenure on the Commission turned into an opportunity when I was asked to serve on the Task Force. The Task Force served a dual purpose, first to preserve and diversify the workforce at the Test Site, and secondly, it was created in an effort to assuage the tensions between Nevada and DOE related to the proposed nuclear waste repository.

Both senators were committed to demonstrating that the Nevada Test Site could continue to serve the state as a valued asset. The NTS is a 1,360-square-mile area about 65 miles northeast of Las Vegas, where nuclear devices were detonated during the 1950s.

They wanted to preserve and amplify the existing workforce but

pivot away from nuclear testing. Senator Reid focused on the economic development opportunities while Senator Bryan explored the chance to advance clean technology through solar and other renewable energy resources. The Task Force recommended the establishment of two entities: the Nevada Test Site Development Corporation and the Corporation for Solar Technology and Renewable Resources. I was subsequently recruited to lead the CSTRR effort. CSTRR offered an amazing opportunity to—again—lead an important effort and to create a new organization devoted to advancing renewable energy policy.

I left the comfortable and prestigious position of the Director of the Nevada Department of Business & Industry to become the CEO of a solar advocacy organization. I loved the thought of becoming a CEO. Just the sound of it satisfied an inner need to exploit the myths surrounding the ability of black women to achieve significant professional success and bridge the public and private sectors.

CSTRR made historic strides that are still being recognized today. Over a short period of five years, we made sizable inroads to be sure, but fell considerably short of expectations. Our goal was to construct a 10-megawatt solar system at the Nevada Test Site.

We engaged in significant negotiations and undertook a competitive process to identify a developer. In the end, we could not execute a contract to sell the power to DOE. Some would argue that these expectations were unrealistic. Others cite timing, Nevada's low energy rates, and an unprecedented, robust economy as the culprits. In 1995, Nevada utilities posted some of the lowest rates in the West. In addition, most energy-related decisions were made in the shadow of pending retail competition and utility deregulation. I believe these issues factored significantly into CSTRR's ability

to convince consumers and policymakers that Nevada's renewable energy technologies deserved the incentives necessary to explore innovative ideas for technology deployment.

It became clear that economics drive customers and customers drive markets. But first, they must be informed, educated, and challenged.

CSTRR represented an extraordinary era of pioneering and ground-breaking advocacy that culminated in advancing the first Nevada RPS in 1997. That standard continues to anchor renewable energy development in the state today.

Nevada has now installed more than 2,700 megawatts of solar. These systems represent installations that now easily surpass the historic and often artificial tests of reliability, aesthetics, and performance.

Certainly, my industry colleagues would argue that renewable energy resources provide the potential to promote sustainable energy solutions that benefit the environment and improve the quality of life for people around the world for years to come. In 1995, if you polled a group of average people with no connection to the renewable energy movement, most would be hard-pressed to explain why Nevada didn't lead the country in solar development. Even to the intellectually curious, consumers also seemed inextricably tied to old images of solar and wind energy sources—ugly panels atop roofs and large farms of windmills. However, amazingly, the recent improvements in pricing, technology, reliability, and aesthetics have all replaced the stereotypical images of the 1970s, 80s, and early 90s. Indeed, many of the most exciting innovations remained trapped in the lab environment for years.

The Secretary of Energy
Washington, DC 20585

February 19, 1996

Ms. Rose McKinney-James
President
Corporation for Solar Technology and Renewable Resources
6863 West Charleston Boulevard
Las Vegas, NV 89117

Dear Ms. James:

Today's Corporation for Solar Technologies and Renewable Resources announcement will have a profound effect in two lasting ways. First, these projects, and the projects that will surely follow, represent a giant step in solar commercialization. It is comparable to the first commercial steps in semiconductors that resulted in U.S. global leadership and the vast industry we call Silicon Valley. Secondly, by including the Nevada Test Site in the Solar Enterprise Zone, Nevada's leadership in converting defense facilities to commercial applications is demonstrated.

Senator Bryan's vision for the Nevada Test Site and his commitment to moving solar energy ahead is responsible for starting us down this exciting path. He created a private/public partnership that developed a work plan to attract private investment. The Department of Energy is proud to have provided technical and financial support to this effort. The Corporation for Solar Technologies and Renewable Resources was chartered, and under your aggressive leadership is implementing, the plan that will move these projects from paper to reality in rapid order.

With the first projects identified, the Department joins with the State of Nevada, Senator Bryan, and the Corporation in the task of finding the public and private buyers for this environmentally preferred source of electricity. Under Deputy Secretary Curtis' guidance and direction, the Western Area Power Administration and the Federal Energy Management Program have started a process to bring these buyers forward.

As the Secretary of Energy, I extend my congratulations to Senator Bryan; the Nevada Congressional Delegation; the Nevada Operations Office; the ENRON, Cummins, Nevada Power/SAIC, and Kenetech Corporations, the Corporation for Solar Technology and Renewable Resources; and, most of all, to the citizens of Nevada for their vision, leadership, and commitment to a solar energy future.

Sincerely,

Hazel R. O'Leary

Hazel R. O'Leary

Printed on recycled paper

Receiving this letter from the Secretary of Energy Hazel O'Leary was truly a remarkable expression of support from someone I admired.

Perhaps the most significant achievement for CSTRR came with the tremendous support within the Department of Energy,

specifically Secretary Hazel O'Leary and the Federal Energy Management Program (FEMP), National Renewable Energy Laboratory (NREL), and the Western Area Power Administration (WAPA). These organizations recognized the value of innovation and agreed to collaborate with CSTRR in an effort to identify federal facilities interested in the purchase, installation, and demonstration of solar technology. We targeted the most important contracting and procurement organization in the world: the US government.

As a result, CSTRR secured over 80 megawatts in commitments from federal agencies for the purchase of solar energy. The process that followed included a targeted message to a customer representing the largest consumer of goods and products in the world, the United States government. Using the federal government as the primary focal point, we embarked upon an aggressive campaign to create a leadership model for the use of renewable resources in the US. This experience also allowed us to identify a number of significant barriers. These barriers became the foundation for detailed review of the obstacles facing the commercial deployment of renewable resources and an action plan.

Without exception, the most significant barriers identified as a result of the CSTRR experience were the economics. Significant challenges of project cost, energy pricing, contract terms, and the general affordability of the solar systems strangled progress.

During my tenure with CSTRR, a significant amount of my time was devoted to public education and engagement. It is difficult to translate the degree of frustration that stemmed from attempts in the mid 1990s to explain the value of "renewable energy resources." So few had any real appreciation or understanding. While there

were enlightened consumers expressing support and appreciation of the concept, most hadn't a clue. One of the most challenging questions researchers faced was explaining why the resource was not more readily available. A typical reaction at the time was, "Call me when I can pick this up at Home Depot or Lowes." Or, "Does this stuff come with the purchase of my new home?" A Nevada favorite: "I love solar, we have an abundance, the fuel is free, so sign me up!"

Have you checked the solar displays at Costco and Home Depot lately?

Today, you can literally walk into a Home Depot and see a display for a Tesla battery pack, or any number of manufacturers of solar panels.

This is how far we've come.

The vast majority of scientists in the world have consistently expressed the view that there is intrinsic value in taking affirmative steps to conserve energy and move to reduce our reliance on fossil fuel. They also focused on the reduction of carbon emissions and redirected sustainable industrial environmental practices. Research suggested that these steps would lead to a substantial reduction in the potential for global warming. Recent horrific weather events and more recent scientific findings have underscored the need to address climate change. The reality of our circumstances has been made clear. The urgent need to identify policies and practices to address this threat has to be a priority. I have dedicated the majority of my professional life to advocating for and advancing policies designed to address this challenge.

For many years I felt isolated and distanced from others in more traditional energy sectors. I was the odd woman out and typically

the only person of color in the room discussing clean energy. I maintained my strong interest in politics and continued to be active in democratic politics, joining the central committee. Ultimately I decided to take the plunge into electoral politics, and with the urging of Senators Reid and Bryan and the support of Governor Bob Miller, in 1998, I entered the race for Lieutenant Governor. What an exhilarating and exhausting experience it became.

Running statewide as an African American woman in Nevada required me to call on a deep sense of commitment to public service. I was convinced that I had something to contribute. I ran for the job that few deem more than ancillary at best. The opportunity to lead the state's conversation around tourism, economic development, and serve as the President of the state Senate was intoxicating. In hindsight, while I was clearly prepared to address the policy, I was woefully unprepared for the politics! But life has a way of resurrecting and righting a sinking ship. Once again, a completely unexpected call introduced serenity into my journey.

I lost that race. My performance was considered more than respectable. Many expected me to jump in for the next cycle. But, that was the job I coveted and nothing else seemed appealing. The unexpected call came from Mike Ensign, the CEO of Mandalay Resorts Group, and paved the way for my long-dreamed-of (albeit secret desire) for an opportunity to enter private sector status. In 1999, I became the first African American woman to join the Board of Directors of a major publicly traded gaming entity. This opportunity immediately propelled the trajectory of my professional and political status. I continued my work in government affairs and clean energy, but balancing my board work with my day job became complicated. It created significant conflicts. The need to

address these conflicts resulted in my decision to heed advice from trusted advisors and open my own business.

My work in clean energy served as an asset in 2008 after the remarkable and historic election of President Barack Obama. I had been an early supporter and committed to his success.

I felt as if I were on a remarkable bridge from 1972 to 2008. While I had been a delegate at the 1972 convention, I was on the floor as an honored guest in 2008, but I wasn't a delegate. I was humbled by the notion that I'd lived long enough to see Shirley Chisholm make the first attempt by an African American for the presidential bid—a thrill in its own right!—and then to see it come to fruition all those years later. I was very emotional and couldn't describe it to others around me. Now, with some distance from 2008, I can say it was life-changing.

After the dust settled, I received the honor of an invitation to join the Obama-Biden Transition team. The Team included my co-author, Carolyn Green. The new Administration extended a commitment to benefit from and to shape policy based upon the input received from voices representing key stakeholders. This commitment provided me with the opportunity to meet the leadership of AABE.

I was thrilled to see this group of distinguished African American leaders, but I wasn't familiar with the organization. That changed rapidly when a former colleague from NREL active in AABE subsequently approached me to consider joining the board. By this time, I was already serving on two public boards, as well as several highly visible energy NGO boards.

I was warmly received and sought out by a group of long-term members representing the essence of the mission of AABE. These women understood the importance of an organization fully devoted

to directing our voice and collective professional and personal wisdom to the benefit of the broader African American community.

My affiliation with AABE became an important aspect of my professional life. These women join me in this endeavor to share our personal stories with an audience of those seeking a similar path in energy. The group seemed particularly impressed with my experience as an independent director. They encouraged me to share that experience and urged me to consider a leadership role with AABE. I was interested, but the thought of another election process was terrifying, as it would dredge up unpleasant emotions associated with failure and loss. But these women were both relentless and incredibly supportive. I won that election, and serving as the Board Chair for AABE became one of the most important opportunities of a lifetime. It was an honor that will be cherished for years to come.

Similarly, upon reflection, my tenure with CSTRR was pivotal. It became the most stimulating and incredibly challenging, interesting, and informative journey of my career to date. It allowed me to maximize every aspect of my prior experience. It allowed me to participate in a bold and meaningful effort. It provided context and purpose, knitting the threads of serendipity into a useful fabric.

I believe my life's experience to date represents the intersectionality of economic development, innovation, race, and empowerment. All have served me well. I also believe that we must continue to ask the hard questions, promote inclusion, and seek the right input to answer the right questions. It's important to acknowledge that none of this can be accomplished in a vacuum.

I am enormously indebted to my grandparents, my mother, my family, and my mentors for their unconditional love and support. I'm grateful to my growing AABE family for providing me with the

extraordinary chance to connect my life's work to the communities that reflect my heritage. But above all, I'm grateful to all who have touched my life and given me the ability to survive, thrive, and break barriers. I am compelled and energized to continue to ask the hard questions.

Biography
Rose McKinney-James

R ose McKinney-James is a seasoned small business leader, clean energy advocate, and independent corporate director with a long history in public service, nonprofit volunteerism, and private sector corporate social responsibility. The former President and CEO for the Corporation for Solar Technology and Renewable Resources, (CSTRR) and former Commissioner with the Nevada Public Service Commission, also served as Nevada's first Director of the Department of Business and Industry. She is currently the Managing Principal of Energy Works LLC and McKinney-James & Associates. Her firms provide business-consulting services and advocacy in the areas of public affairs, energy policy, and economic and sustainable development. This provides an opportunity to advance her extensive experience as a business, corporate, and community leader. Rose has over two decades of experience in advocacy in legislative and utility regulatory proceedings relative to renewable and clean energy policy and community and stakeholder outreach in Nevada and the US. She has helped to shape much of the energy policy framework in place in the state of Nevada. A registered lobbyist with the Nevada Legislature, Rose currently represents a range of public and private entities with interests in regulatory and energy and public policy.

She assists her clients by developing strategic plans and initiatives designed to be executed utilizing solutions that address unique circumstances and demands.

Working with a diverse group of advocates, Rose lead the effort to facilitate the passage of the first Renewable Energy Portfolio Standard (RPS) in Nevada. This was the first of many successful collaborations resulting in significant clean energy policy advancement in the state.

Rose serves on the Board of Directors of MGM Resorts International, MGM Detroit, and Toyota Financial Savings Bank. She also serves on the Boards of the Energy Foundation and Net Impact. She is the Immediate Past Board Chair for the American Association for Blacks in Energy (AABE). In 2013, she was selected to serve as an Inaugural Ambassador for the C3E initiative supporting increased participation by women in the clean energy sector. She is the past Chair of The Clean Energy Project and Chair Emeritus of Nevada Partners, a nationally recognized workforce development agency.

Rose has been recognized by the US Small Business Administration as Small Business Advocate of the Year. She received a Lifetime Achievement Award from the Women's Chamber of Commerce as well as the Clark County Public Education Foundation. She has also been honored by the American Solar Energy Society (SOLAR NV) as the Advocate of the Year. Rose is listed in *Savoy* Magazine Power 300 among the most influential African American Corporate Directors.

A native of Detroit, Michigan, Rose is a graduate of the Antioch School of Law in Washington DC, and received her BA from Olivet

College in Olivet, Michigan. In 2013, Olivet honored her with the Distinguished Alumna Award. She is married and the mother of two sons.

My Road Map:
Powered By Electricity ⚡

by Hilda Pinnix-Ragland

"Life is difficult. It is a great truth. Once we see truth we transcend."

—M. Scott Peck, MD

Throughout my life, *The Road Less Traveled* by M. Scott Peck, MD has been my favorite book because it's a testament to the power of pioneering your own path. The title of this 1978 bestseller closely aligns with my journey of almost 40 years in the gas, electric, and renewable-energy industry.

Even today, as a *re-wired* corporate board executive—and oddly enough, co-owner of Pinnix Pecans, LLC located on the family farm, which has survived five generations—my road continues to evolve with exciting twists and turns.

This has been my story since childhood, and it truly has allowed me to make a difference in the business world and beyond.

One defining moment occurred as a 13-year-old, when I eagerly accepted a job pumping gas for 50 cents an hour at one of our family member's local stores on Highway 49 in Burlington, North Carolina. It happened while my dad and Clyde were talking about

family and crops, and we were standing around one of the large, white trucks used to haul tobacco and other commodities to markets. Working for a family business requires you to perform almost all duties.

I announced, "If you need another person to help at the store, I can do a lot of things."

Earning money, asking, and walking the narrow line as a child and as an adult were not unusual for me. After all, I was the girl who told my father, "I can hammer a nail, use a screwdriver, drive a tractor, herd beef cattle, and even plant corn." My parents and Mrs. Bonnie B. Davis, my 4-H advisor, taught me Best Farming practices, and beef cattle farming would later earn me the unique distinction of the 2008 NC Lifetime Achievement 4-H recipient, an honor received by few women. I was the first black person to receive this award.

My tenacity and drive to succeed at everything caused me to ask bold, probing questions and declare my abilities. For example, one day I announced:

"Dad, if you pay me, I can plant all of the corn."

Dad looked at me in dismay and responded, "Bronner, I am sure you can!" This was his mother's name. He often said, "Bronner will never die," as she lived in me. I loved and clearly related to "MaMa." Although short in stature, she was a strong leader within the family and a community doctor and businesswoman who commanded ultimate respect.

Her family, the Corbetts, were the largest minority landowners in Orange County. They built the school, church, and store in the small Cedar Grove community. We would be among the first to integrate schools, largely because we owned and operated our own

properties. During integration, our parents walked my sisters and me to the bus stop as we boarded with the US Marshals. My heart raced each day as I intently watched every move during the ride to Aycock Elementary School.

In many ways, Dad would also carry the legacy of his forefathers and parents with continued community engagement, activism, and support. He would raise funds for: the Oxford Orphanage (currently The Oxford Home for Children), asking us to share our things with homeless kids; Piedmont Health Center, walking door-to-door to ask for funds; and college money for deserving young people. He always said, "To whom much is given, much is expected." His gravestone reads his favorite saying: "God first, Education and Family!"

Dad lived his legacy at the farm after serving around the world in the US Air Force during World War II. He even went on to earn his Master Welding degree to launch a successful welding business on the family farm and in the surrounding community.

He always made me feel I could do anything; this included using a gas pump for equipment on our farm. As the second of four girls, I was always the one who would take on the tough tasks and try new adventures. Hearing customers drive up and say, "Fill 'er up!" resonated as my way to help Clyde earn profits.

"Cha-ching!" I often said.

We affectionately called the convenience store "Clyde's," since he was the owner and operator.

At age 16, I also became a bus driver for elementary school kids and was ultimately awarded the "Best Bus Driver of the Year." My first car, a 1962 black and white Chevrolet with a red interior, would come from the principal of the elementary school with a

whopping $25 price tag. This was actually the cost for the car title. Mr. Davis, the principal, said, "Pinnix, you are not only smart, but a hard worker and definitely driven to succeed!" He was Mrs. Bonnie B. Davis' husband.

Working two jobs while actively immersed in extracurricular activities—such as the Student Government Association's Treasurer, French Club President, and competitor in track and other activities—left little or no time for idle play.

Many of my lifetime lessons and treasures were taught by customers at Clyde's, who were mostly family members or close family friends. In fact, my decision to attend North Carolina Agricultural and Technical State University was confirmed when Dr. Graves, Dean of the Biology Department, stopped by for lunch after hunting. He shared his positive views about why I should definitely select North Carolina A&T State University, and he offered me a full scholarship. Dr. Graves' precise words were:

"A&T was good enough for your older family. Why isn't it good enough for your new generation? Remember, they were not allowed to go to white colleges!"

It was almost as if he were questioning me to say, "Why not?" This made a difference for me. Of course, the 100 percent scholarship sealed the deal. Several generations of family members attended A&T, including my Uncle Charlie, who graduated from and taught in the Mechanical Engineering Department to educate future Aggie engineers. My Aunt Anne was an NC A&T graduate who was an Accounting Manager at Howard University for many years, and my Uncle Frank Willingham is in the A&T Football Hall of Fame. Walking around campus, I was always aware of evidence that several generations of family members had left legacies.

When analyzing the college decision, I was more concerned about having my freedom and avoiding the need to stay off campus with my Aunt Pearl and Uncle Charlie.

My desire to major in accounting and to write my thesis in graduate school about underground gas tank testing was inspired by the dialogue I heard at the gas station, as well as my experience there while helping with payroll and designated accounting duties. Mathematics came somewhat naturally for me. As a result, I enjoyed performing the underground gas tank testing to determine the amount of gas evaporation or leakage. I continued to earn this invaluable, real-life training by working at the gas station throughout my freshman year and halfway through my sophomore year. I enjoyed earning my own money.

A sudden, shocking telephone call came during the spring of my sophomore year, when I received the news that Clyde had committed suicide. It was indeed one of the saddest days of my life; Uncle Clyde left an indelible mark on me. One of the lessons from this experience was: "Keep your mind and body strong, and don't let life's ups and downs get the best of you." My faith supported and carried me until the semester ended. My grades remained stellar, with a 4.0 GPA for the semester in honor of Clyde.

I am extremely grateful for the outstanding financial and leadership support of my accounting professors, especially Dr. Quiester Craig, Dean of the Business School. Although he sometimes scared us, he is indeed a phenomenal and visionary leader with exemplary execution of results. My competence, confidence, and courage were set in stone during this time. Not only were we strong accounting students, we were also leaders in the Student Government Association, as well as the Alpha Chi and Alpha Kappa Mu honor societies.

Thankfully, Dr. Craig helped set me on a path toward success as I completed my undergraduate degree with high honors and enjoyed prestigious positions with Arthur Andersen and Colgate Palmolive companies as an Auditor and Accountant.

My experience with Colgate began during the first semester of my sophomore year, when I was selected from several applicants for this internship that typically was awarded to juniors and seniors.

Despite having offers nationwide, I felt compelled to accept the internship as a Colgate Scholar in New York because they provided the funds to Dr. Craig for a strong academic student, and I was the only recipient of the 100 percent fully-funded Colgate scholarship. Colgate also awarded me two incredible summer and winter internships. Thus, I had no choice but to accept their offer of full employment as an Accountant for Bancroft tennis racquet, Palmolive detergents, and Ram Golf business lines. Both companies were located at 300 Park Avenue in Midtown Manhattan, directly across from the famous Waldorf Astoria Hotel.

The wonderful internship and Colgate scholarship fully paid for my tuition, board, fees, and even a nice, off-campus apartment while attending A&T with my dear friend Yvonne Anders. We were both accounting majors and fortunately earned full academic scholarships.

During my internships, I stayed with my Aunt Bernice and Uncle Luke in Connecticut. I rose each day at 4:00 a.m. and drank my uncle's freshly blended, green vegetable smoothie for breakfast. Then I boarded the train to New York City alongside Wall Street professionals, often as the only person of color. This was quite an adventure for a 19-year-old young lady from North Carolina!

Working as a tax tutor during my junior year provided additional spending money. Earning my own money was essential then

as well as today. After all, my two sisters, LaRosa and Condoza, were headed to college. I often thought about how difficult it was for my dad, preparing to have college tuition for all four of his daughters at the same time.

"Don't worry," he would say. "I can sell some beef cattle."

Thanks to scholarships, he never had to sell the cattle for our college tuition.

Family and friends have played a significant role throughout our lives. For example, the FedEx driver for UNC was a relative who delivered Mom's homemade goods to my sister LaRosa at UNC-Chapel Hill. My dorm manager and the dean of students were also family. And Mom's principal, Mr. W.I. Morris, along with her cousin, managed A&T's Career Development. We were surrounded with lots of love and support.

I was given a wonderful blueprint and map for success amid New York City's work life, flashy lights, and continuous sirens and horns. Many of my experiences, having come from the rural South, were beyond the reach and reality for girls and people of color during that era.

As children, we often traveled through New York to visit our family in Connecticut. At the time, Connecticut was mostly rural and had "blue light" laws that placed strict regulations on what a person could or could not do there. In contrast, New York was intriguing and exciting.

I can still hear and visualize the commotion outside the Waldorf Astoria when streets filled with taxis and black limousines came to a screeching halt to allow Queen Elizabeth of England, and later Princess Diana, to enter the hotel. Everyone hurried to the window to catch a glimpse.

Just over one year into my time at Colgate, the Audit Manager from Arthur Andersen stopped by my desk to ask if I was ready to go into public accounting. Fewer than three weeks later, I moved from an office on Park Avenue to work at 54 Avenue of Americas, which is Sixth Avenue. The overall environment was stoic and conservative, with a Wall Street-style dress code dictating: navy blue, black, or dark gray suits; pumps no higher than three inches; and white, light pink, or light blue blouses.

The low representation of female auditors and blacks became clear as I entered and successfully completed the intensity of St. Charles Audit Boot Camp outside of Chicago. Public accounting offices were largely male-dominated in the 1970s, and the New York office was no different. The success of training often aligned with the type of audit assignments.

I was very fortunate to meet Ellen, a female Audit Manager who approached me in the ladies' bathroom to say, "You did well!"

My inquisitive personality responded, "What does that mean?"

"Your first audit is on Wall Street with Bache Halsey Stuart Shields, a brokerage client, and I am your manager," she said. "You were assigned Consumer Products, which was your first choice."

After Ellen and I returned to our offices, I immediately started preparing for the audit on Wall Street. Understanding details regarding stocks and bonds, selling long and short, determined my future success. In addition, preparing the audit schedule, transactional flow analysis, and statistical sampling required focus and attention.

Throughout these experiences, I was always thankful, as my grandparents and parents had taught me to be.

In New York, I learned and understood more about the various religions, especially Judaism. My colleagues, Ellen and Rich,

both Jewish, often engaged in conversation and shared information about Jewish practices. My knowledge of countries, cultures, businesses, and diversity expanded as we continued to work together. We developed great friendships while traveling throughout the world, auditing companies. After all, our lives were consumed by working long days, nights, and weekends; 70-hour work weeks were the norm.

Future assignments would include: Keene Lighting, a lighting manufacturer in New Jersey; Texaco Oil; Standard Brands; Academic Press; Burns Security; and Estée Lauder. The Burns Security, Keene Lighting, and Estée Lauder audits would advance my career in public accounting and strengthen the next chapter in my career.

Returning To The Energy Industry

On May 9, 1980, my energy career resumed, thanks to a call from Carolina Power & Light (CP&L), asking if I was interested in returning to North Carolina. Shortly afterwards, I accepted a position in the Auditing Department.

At the time, I was engaged to be married, sewing the last of the bridesmaids' dresses alongside my dear friend, Cheryl. With the ceremony two weeks away, I already had my gown and gifts from the wedding shower. Thanks to some great questions from Cheryl, I canceled the wedding.

The scientist in me applied a quantitative approach to explore my deeply personal decision; I used what we call in business a *Force Field Analysis with pros and cons*. This comprehensive method enabled me to evaluate key characteristics for an ideal husband. Fortunately, my decision was confirmed by a low compatibility score.

Although the gentleman was very nice, I didn't believe he could have accepted my ambition to shoot for the stars. I was sad to cause him heartache; nevertheless, I returned my dress—and never looked back.

Cheryl and her husband also relocated to Raleigh from New York. Today, our homes are still within walking distance. After all, Cheryl and her husband, Jerry, are our daughter's Godparents and we are their children's Godparents. Traditions and relationships are important. For 34 years, we have hosted our annual Christmas Eve dinner with all four of our Godchildren: Nic, Bree, and twins, David and Matthew. The twins' mother, Beverly, is our daughter's other Godmother. Beverly also announced retirement the same day as mine. We now travel, farm, and explore new horizons together.

Back then, life in Raleigh was more quiet and reserved, as compared to New York. At age 25, I purchased an older house that required a few renovations near downtown on Martin Street, which was within walking distance from Cheryl. Weekends were spent installing a shower and ceramic tile, stripping furniture, painting, and mowing the lawn.

As an auditor who traveled extensively, the quietness of the weekend was wonderful. My funds were limited because I had a mortgage to pay, along with the essential household bills, including a Volvo with no air conditioning. Peanut butter sandwiches became my favorite lunch. I managed my money by setting aside at least 10 percent of my salary each year and followed my uncle's advice to the T about never taking funds from my retirement/savings account. Building a nest egg and equity for the long-term was expected. My family would say, "Don't just live for today," and "Don't try to keep up with the Joneses."

They also taught me that happiness comes from within. You can make yourself productive and happy by learning new skills. I did this as an internal auditor for an energy utility company with coal mines in Kentucky and West Virginia, nuclear and fossil plants, and customer offices/field operations in small towns.

Learning how to play golf became a valuable skill for future positions. As life would have it, golf would become a great opportunity, just as it was for my great Uncle Dewey Brown, the first African American PGA golfer. On a golf course, many decisions were discussed, then and now in corporate America. Playing golf was an essential skill in economic development. To prepare and equip females with this core skill, in 1999 I hosted an all-female executive golf clinic with the first LPGA female golfer, Peggy Kirk Bell, at her golf resort in Pinehurst. I was determined to make sure women understood all aspects of the economic development model.

Demonstrating the change, even if subliminal, was inspired by a desire to see benefits to ourselves as individuals and for future generations. My role enabled me to be the catalyst and conduit for impacting change.

Marriage & More Responsibility

On a beautiful fall day in September 1981, I met my future husband while delivering my roommate's resume to Human Resources Manager Al Ragland.

Little did I know that it was a set-up; my friends, including the VP of Audit and Human Resources, had orchestrated this meeting for me to meet Al, under the guise of trying to help my roommate get a job.

We clicked. Al quickly introduced me to his aging parents,

asked for a date, and proposed after nine months. He was on a mission, and fortunately, I fell for it.

"Will you marry me?" he asked on one knee as every Treasury Department employee watched intently. I was so embarrassed and happy at the same time. His proposal in our workplace illustrates our deep connection to the energy industry. Now, 35 years later, we are as happy together as we were back then.

Newly engaged, my life was moving at warp speed. I was accepted into Duke University's Fuqua School of Business, thanks to a 100 percent scholarship approved by Carolina Power & Light Company CEO Sherwood Smith. The funding hinged on my excellent academic performance.

In order to plan my wedding, however, I postponed graduate school for one year. Thankfully, Duke University and Mr. Smith approved and understood my request to defer.

My wedding was a dream. I had the help of angels in the form of the Altar Guild at St. Ambrose Episcopal Church, especially the Directors, Mrs. Jeffries and Mrs. Anders, along with Mrs. Willie Otey Kay, my seamstress. Almost every aspect was linked to St. Ambrose, including the soloist and choir member, Mr. Watson. Al and I also received intense faith counseling by Father Calloway.

My wedding party was just as busy. Bridesmaids Cheryl and Barbara were both expecting babies. My maid of honor and sister, LaRosa, was consumed by dental school.

After the wedding, I excelled in the two-year graduate program at the Fuqua School of Business at Duke University and earned my MBA in 1986. I was also promoted to the Treasury department as a lead Financial/Tax Analyst, developing the tax assessments and models for financial evaluations. The industry and company were

going through critical times with the construction of what is now the Harris Nuclear Power Plant, record interest rates, and a deficit of available capital.

Shortly afterwards, I was asked to work on prudency audits for all of our nuclear plants with the Nuclear Regulatory Commission (NRC). The prudency audit recognition clearly propelled my career not only for future leadership positions, but also for today's corporate boards on which I serve.

Destined to examine the core business model for the electric utility business, my conversations and in-depth dialogue continued to question *what, where, how,* and *why* as the nuclear market experienced devastating regulatory strain. Significant blows occurred with: Maine Yankee Nuclear Power Plant; the fire that collapsed at Japan's Fukushima nuclear plant; and Pennsylvania's Three Mile Island nuclear disaster.

My work on these issues culminated on my 30th birthday, when I worked all night alongside the Treasurer to convey the criticality of the company's financial constraints. Despite the all-nighter, my dear husband sent a beautifully decorated cake with 30 candles. One of my crazy colleagues had the nerve to light all 30 candles.

Celebrations ended there, as an industry shake-up triggered cut-backs and salary reductions that were proportionately based on income across the company. The CEO took the first salary reduction. I was shocked and somewhat concerned, as this was a lesson for everyone. When the chips fall, companies are neither indispensable nor immune, and it's important for a leader to set the tone. Our new CEO Mr. Sherwood Smith was indeed a strong leader for the entire energy sector. He had recently assumed the CEO position after the sudden death of his predecessor, Sherron Harris.

Succession planning became a new reality for me as a young professional. In addition, when everyone is impacted, the team must refocus by working collectively on the common goal of survival. Our Harris Nuclear Plant was the last to be constructed for many years to come. It was indeed a struggle to essentially leverage the company while building a new nuclear generating plant.

Career Turning Point: Black Organizations Are Relevant

In February of 1983, while going through my daily mail, I opened a letter from the American Association of Blacks in Energy (AABE). The professional organization was inviting Carolina Power & Light to participate in its annual conference in Columbia, South Carolina. The correspondence included our CEO/President Sherwood Smith as a keynote speaker, along with a notable brain surgeon, Ben Carson, MD.

After reading the letter a few times, I asked my supervisor if employees could attend. This was truly a bold move at the time, because financial analysts in Treasury or non-supervisory employees kept to the core work. My supervisor immediately told me to talk with our department head, the Treasurer, who said, "This looks good." The same day, he invited me to join him in the CEO's office to discuss attending the AABE conference. As a young, enthusiastic, career-driven employee, I immediately prepared a document depicting the driving and restraining forces. Needless to say, I was a tad nervous, because my simple idea evolved more quickly than I had expected.

Our CEO was delighted and wanted to know my strategy if offered the opportunity to attend. Lacking details about the event

and the other companies involved, I used the simple invitation letter to prepare an overview. I suggested that we have the six highest-ranking minorities in our company attend to obtain information, glean education, and prepare a recommendation.

The six of us were on a mission! Extremely grateful that our CEO was supportive of this endeavor, we wanted to make the most of it to benefit ourselves and our company.

Attending the conference was a literal lightbulb moment for me, because it illuminated in a profound way that the energy field was far more vast than I had, until then, perceived it. Joining my peers from energy companies across America also convinced me that I had the power to really help educate African Americans in many ways.

I became active in the local AABE chapter, and was proud when the highest-ranking African American person became president. The organization paved the way for the upward trajectory of my leadership in the energy field.

We connected and developed lifelong friends, including: Josie Clairborne of South Carolina Electric and Gas; Chris Womack of (then) Alabama Power; David Owens of EEI; Robert Hill of the American Gas Association; Rufus Gladney of Consumers Energy; and Jim Davis of Georgia Power. We also celebrated the AABE founders: Rufus McKinney, Bob Bates, Linda Talifero, Clark Watson, our beloved Jimmy Stewart, and his lovely bride.

I will always cherish the strength and energy derived from this moment in time. Shortly afterwards, we formed the Raleigh, North Carolina Chapter, followed by the North Carolina/Virginia Chapter, and finally, the North Carolina Chapter. All major energy companies and universities were involved. Meetings were held after

hours and on weekends throughout the two states, and included a strong scholarship program to involve more African Americans in the energy industry. We personally funded two scholarships for deserving high school students majoring in a STEM field. This endeavor would eventually grow to support 10 students.

All the while, the American Association of Blacks in Energy network afforded me the unique opportunity to learn, grow, and develop a wealth of energy, knowledge, and expertise. It also enabled me to develop a lifelong "kitchen cabinet" of sister-friends and AABE family. My sister-friends—Carolyn, Joyce, Telisa, Rose, and Stephanie—quickly evolved to become widely known throughout the organization.

Several of us served on the board of AABE for more than 25 years. During board meetings, we didn't need to verbally speak, because each of us would "read" the others' perspectives. We were clearly on a mission to have a financially sound, strong, organized, and efficient board meeting that was deeply grounded in strong governance.

When we began, very few females held leadership roles in the industry. In fact, all of us were the first women officers in our companies. We are grateful for several energy industry executives who made a tremendous impact on promoting female leaders on the board and ultimately as AABE officers. These individuals include: David Owens, senior executive at Edison Electric Institute; Dan Packer, CEO of Energy New Orleans; Bob Harris, General Counsel of Pacific Gas and Electric; and several others.

During this time, our first female Chair, Mary Boyd Foy of Con Edison, was elected. Progress is not always smooth; the organization experienced significant turmoil resulting from several changes.

Taking a lesson from North Carolina A&T State University, I elected to never forget that each of the successes we achieve in this life are because someone helped us along the way, even just a little. I did not accept a board position until I was encouraged by Jim Davis and others who suggested and supported me for a board position. We must always take time to thank that person and carry that gratitude in our hearts.

Throughout my service to AABE and my core energy career, I was motivated by a spirit of dedication to learning, discovery, and community engagement. This attitude was clearly aligned with my roots and foundation while growing up as the fifth generation of landowners/farmers. My soul was deeply anchored in the soil, cultivation of the future crops, and a belief that all things are possible through education, family, friends, and a strong faith. Knowing my value and net worth to the world in which I reside had a new meaning.

Progressing In The Industry

Over the next 30 years, I was selected for several significant leadership opportunities both within and outside the company. Learning all aspects of the business remained a priority; thus, I would soon be promoted from the Treasury Department—where I was working on bonds, writing tax models, performing financial analysis for the nuclear plants—to Total Quality Management. In that position, I handled strategic planning for Operations. This newly-formed department's core mission was "Reorganization for the Entire Company," and as the project leader, I was tasked with re-organizing the distribution and transmission areas, which were part of the operations side of the business.

Reorganizing often meant "layoffs."

My audit and financial knowledge were critical for overall business success. The missing link for me was a working knowledge of the operations sector, which has traditionally not been accessible to women due to its heavy reliance on STEM: science, technology, engineering, and math.

Although I felt that attaining a leadership position in this realm would never be possible, I was, indeed, promoted to Project Manager supporting the fossil operations and customer operations functional efficiencies. To do this, I took classes to learn this aspect of the business, thus trailblazing a new path for other women and people of color to follow me. And in this leadership role, I was able to effectively reorganize.

I was fascinated to learn about how to generate electricity from five key processes: 1. Using coal; 2. Uranium for nuclear power; 3. Hydro/water plants; 4. Gas-fired; and 5. Clean energies such as solar and wind power.

So I moved from a financial acumen to understanding the customer, and comprehending how electricity is generated. That's a skill set that few of us have, and it was thrilling to learn and contribute in this new area. Working directly for the key officers and leaders within both business lines prepared me for a totally new experience.

Immediately during the Transmission and Distribution reorganization announcement of new leaders, I was asked to meet with the Chief Operations Officer and Executive Vice President. Needless to say, I was very nervous and uncertain about the nature of the meeting. They actually offered me the significant promotion to District Manager of Distribution Operations for municipalities of Cary (the

highest-growth area in the company), Pittsboro, Research Triangle Park, and Siler City.

I became the first woman with the responsibility of line and servicemen, engineering, customer service, meter reading, and community engagement. It was indeed a tremendous challenge. New companies were entering the Research Triangle Park every day in my newly assigned district, and the world's largest, privately-held software company, SAS, was a customer.

Constructing, maintaining, and engineering power lines opened my eyes and expanded my knowledge in many ways. I would approach the position no differently than other leadership roles: first, I would get to know the people; take additional courses to learn electrical power operations at NC State University with Dr. Grainger; learn the regulatory laws; and embrace customers and the community. A kitchen cabinet soon developed to support me with: the Line and Service Supervisor, Bobby Crocker; Engineering Manager David Timberlake; mayors; local chambers of commerce; our Account Manager; and later, Community Relations Manager, Marty Clayton; and one of my lifelong friends, Kathy Hawkins.

It was then that I received the inside information and key aspects of the job. In addition, I had to learn how to wear a hard hat, along with the other PPE (personal protective equipment) while developing people, performance, and excellence in the workplace. Even today, they are my trusted friends. Three months in the position, we reorganized again to strengthen efficiencies and overall effectiveness of the workforce. I was coached to step up my leadership skills by selecting only the most talented, and I did.

In the midst of the reorganization, Hurricane Fran devastated the entire service territory and almost all of North Carolina. The

hurricane winds jolted me into a stronger leadership style as we coordinated external and internal crews to safely and quickly restore power for 95 percent of all customers. First and foremost, with my husband out of the country, I had to juggle arrangements for our six-year-old daughter, Katherine, as well as the office with convoys of utility workers from several states. A dear friend, Peggy, and her husband, Don, kept our daughter safely throughout the roaring winds of the storm until my sister arrived to care for her. Our cat, Midnight, vanished during the storm and never returned.

As a mom, I was successful at work when I knew Katherine was happy, safe, and secure. Being a perfect mom was clearly not the goal, because I continue to learn about motherhood. My daughter is, indeed, one of my proudest accomplishments. Katherine successfully earned her undergraduate degree at NC State University and graduate degree at Emory University's Rollins School of Public Health. Her work ethic is impeccable, as is her beautiful, engaging, and caring personality. Most importantly, she is a wonderful mom to our dear granddaughter, Kenley.

In the aftermath of Hurricane Fran, my husband Al was totally unaware of the damage because he was working in Sweden with limited telecommunications access. Over the next three weeks, we restored power, often working 24 hours at a time. Pulling wire, walking the streets, communicating with the media, and moving trees became the norm. Once power was restored at our house, I invited those without power to stay at my home. As for my accommodations at the time, I was sleeping on the floor of my office. I literally slept at work to oversee our round-the-clock efforts to restore power.

Two other significant events occurred while working as the

District Manager. First, during a Corporate Glass Ceiling Audit, I was asked to participate on behalf of the company. Our legal counsel, Bill Johnson, interviewed me. Bill became my mentor and later sponsor. He was my Executive Vice President while I was Vice President of Economic Development; he later became my CEO.

By this time, I had successfully managed working with four CEOs, several reorganizations, and three mergers.

Second, during the reorganization, black leaders—all six of us—developed and presented the business case for diversity to our CEO. Strategy meetings were held in my Cary office after work and on Saturdays. I called the CEO's office to schedule the meeting and he invited the EVP of Human Resources. The evening before our meeting, four of the six managers dropped out, saying, "Hilda, I can't risk losing my job! I am so sorry."

My stomach hurt and my mind raced with intense anxiety. Had I done the right thing? Then I reflected on the fact that my strong, courageous grandparents and parents had been instrumental in advancing human rights. I also thought about my experience integrating schools in Orange County. This bolstered my determination to persevere when others were afraid.

I called James, the Human Resources Manager, to rethink our strategy. James and I were determined to move forward at all costs, because it was indeed the right thing to do for future African American employees. As a result, James and I led the effort during the CEO presentation. He focused on internal cultures, and my segment aligned with the external market and the community. While intense and stressful, the meeting was successful.

Shortly afterwards, we were promoted to new positions where we could not only "talk the talk," but also demonstrate our

leadership abilities. It had been risky to schedule a meeting with our CEO to share our concerns regarding blacks being disproportionately dismissed during reorganizations because no seat at the table was supporting them.

The overall success of managing Hurricane Fran would soon lead me to additional promotions that included running the CP&L Foundation, with direct responsibilities to the Corporate Board of Directors. Within 18 months, the Vice President of Economic Development position opened.

By then, the company had new leadership: CEO Bill Cavanaugh and COO Bob McGehee. Both were recruited from Entergy to totally revamp our struggling nuclear operations. Both were instrumental in my overall success at a time when I had lost hope for the advancement of women and people of color in corporate America. I had started to believe that the glass ceiling was actually a steel ceiling for women, especially for blacks. Despite this pessimism, my goal was to help blacks and women advance into executive offices in the energy industry.

While I was quietly working in my office one day, Bob McGehee walked in to discuss the NC Zoo contribution. He was enamored with one of the ostrich eggs that I kept on display.

"Oh, I love that," he said. "You're as odd as I am. I love nature, and I love animals." He held the egg in his palms like a precious, fragile ornament, and said, "Wow, I really like this."

I later took the egg to his office as a gift. Little did I know, he also came to ask me about the open Vice President position.

"This company," I said, "will never have a female, let alone a black, in the all-white male Economic Development leadership role."

"I believe, do you?" he responded.

Although Bob and I believed in me, some others did not refrain from expressing their unreadiness. As my manager introduced me to a county economic developer, the county developer abruptly said, "Has CP&L lost its mind sending a woman, let alone whatever race she, is to lead Economic Development?"

Infuriated, I responded, "I am here to recruit new industries, increase jobs, and add tax base to strengthen your education system."

He responded, "Well, we will see what you can do."

I said, "Watch me. My results will speak for me!"

When we work together, the Energy and Economic Prosperity increases.

Bob and I had established a very good relationship, although I still couldn't believe that this white man from Mississippi really cared about African Americans. I was definitely wrong, because he would demonstrate support not only for people of color and women, but also for employees with different sexual orientations. He was truly a God-sent angel. The company became one of the most progressive among the Edison Electric Industry. His untimely death shocked the entire industry. I lost a dear colleague and friend. I will always be grateful because he believed in me.

Bob clearly knew that I would be promoted when he came into my office. Afterwards, I would say to my mentees, "Do you believe?" He gave me much-needed confidence at one of my low points.

Thankfully, I shattered the glass and black ceiling, making history in 1998 when the executives and the board of directors approved me to become the company's first African American female Vice President.

At the time, I was one of only two women officers in economic development among all US energy companies. The other was Becky

Blalock at Georgia Power Company. We were promoted around the same time and later became dear, supportive friends and colleagues. In our role, we often traveled throughout the world—to Korea, Japan, Europe, China, and Scandinavian countries—to secure and attract new businesses to our service territories. Georgia Power set the model for economic development, and I was determined to extract best practices. A rediscovered and expanded knowledge of previously visited and new countries continued, thanks to an introduction to a brilliant Utility Commissioner and now trusted friend, Allyson.

She also introduced me to the world of orchids and other treasures.

My next officer positions with greater authority and compensation included: Vice President of Energy Delivery Services— Transmission and Distribution; Regional Vice President of the Northern Region (the company's largest and most active region); and eventually, on to report to our CEO Bill Johnson to lead Corporate Public Relations. In this role, I had the opportunity to develop a new department, working with local, state, and federal government officials, as well as supporting our international businesses.

In the midst of my role as Regional Vice President, I was nominated by the bipartisan NC Community College Board to become the first female and first African American to chair the board in its nearly 50 years of existence. The Board oversaw a network that included 58 community colleges providing instruction for about 850,000 students.

Historical legislations were passed under my leadership:

- University Articulation Agreement;

- Undocumented student admissions policy; and

- Approval of the largest higher education school bond.

I want to express immense gratitude to several governors for the appointment. North Carolina Governor Jim Hunt launched the effort while we were traveling in Buenos Aires, Argentina. He would continue to be supportive and connected throughout my career. Today, we both sit on the same corporate board—8 Rivers Financial Capital, an energy and technology company. This position took me to a board meeting in New Zealand, where 8 Rivers may build a hydrogen plant.

This position also enhanced my opportunities for future corporate board seats, namely RTI International, and it resulted in my selection work as co-chair of the transition team for Governor Bev Perdue, North Carolina's first female governor.

My last official position utilized all past experiences and knowledge, as I developed and led the Corporate Public Affairs organization. In this capacity, I worked with federal and state officials to secure responsible energy policy for the entire company, including international interests. This was one of my most challenging, yet fulfilling positions.

An integral part of my job involved meeting and interacting with presidents, governors, members of Congress, and state lawmakers. Maintaining a bipartisan perspective while developing responsible energy policy was essential. It was not unusual to receive a call from the offices of one of the 50 governors, federal officials, or even the President of the US. While this was exciting, after awhile it can totally consume your life. Weekly travel lost its intrigue and became "the job."

Although I traveled extensively, I refused to ever miss a family event or my turn to care for my mom during her final 10 years. This was so important to me that Mom accompanied me to one of

my AABE meetings in Houston. It was my weekend to keep her, and her sister Anne lived in Houston. As we entered the Houston Hilton, several AABE members greeted me with hugs as I helped Mom with her walker.

"Who is this lovely lady traveling with you?" they asked.

"It's my mom!" I said proudly. My AABE family then extended a warm welcome for my mother.

Another significant juggle was for my niece Erica's wedding at the Rock of Gibraltar. This was not easy, but I was determined to leave the Republican National Meeting and travel through Ireland with my sister and her husband, then over to Spain for a short car drive to the Rock of Gibraltar. Fortunately, we made it. I will never regret making sure family was first.

Looking Forward: Strategies For Success

A lot of people ask me my thoughts on leadership and strategies for success. While it is important to set personal goals, my approach has always been to focus on making those around me successful, rather than just myself. All of us who are a part of the Pinnix family and the NC A&T community know this, because we were educated and grounded in strong, supportive principles. Today, we call them "servant leadership principles."

It's amazing what can happen—and the problems that can be solved—when you shift your energy and focus away from yourself and toward others. To do this, several Biblical sayings are relevant: "Love thy neighbor as thyself;" and "Do unto others;" and "Give and you shall receive abundantly."

I encourage everyone to think about your most important stakeholders on both professional and personal levels. These individuals can include peer employees, communities, customers, mentors,

mentees, family members, and friends. Ask yourself, "How can I add value to their lives? And how can we serve someone else's highest priority?" This is not easy to do, but it definitely works. As you contemplate reframing your definition of success to focus outwardly instead of inwardly, the results may surprise you.

Helping others while working hard accelerated my ascent up the career ladder at an almost uninterrupted pace, with promotions every two to three years—in uncharted territory for women and African Americans.

"Keep up the great performance!" I continuously heard until I reached the level of executive officer, which was approved by the board of directors. Of note, I learned this the hard way in my first officer role as the Vice President of Economic Development. My focus at the time was all on how to double the estimated revenue stream of new energy users, increase jobs, and let management know about it. At my annual evaluation, I received: a great review for exceeding financials; a nice bonus; and a copy of the book, *Flight of the Buffalo: Soaring to Excellence, Learning to Let Employees Lead* by James A. Belasco and Ralph C. Stayer.

Clearly, this was an incredible learning opportunity for me, and a path forward for other women and African Americans in the future. It is all about People. Yes, performance and excellence are critical, but without *people*, nothing happens. People performing excellence works.

Mentoring Young Women In Corporate America

Mentoring and supporting young women are the most critical elements of my legacy. Here's what some of my phenomenal female mentees have to say. Each passage beneath her name is in her own words.

Sharene Pierce: Developing A Personal And Professional Growth Plan

In 2003, our company had web-based, professional modules available to any employee who desired self-paced career development. I completed one of the modules on professional presence and was directed to share the report with someone in the company who could help me understand the results and develop an action plan for improvement. Although I did not personally know Hilda, her reputation within our company was one of admiration and utmost respect. Who better to help me understand these gaps and develop a plan to improve? She graciously accepted my request.

During our first session, she helped me understand executive presence. I asked for candid feedback and she shared advice that I am still using today. I learned that my confidence in my skills as an engineer was just as important as my confidence in the outfit I wore to an important presentation. Once she saw my commitment to applying her advice and my openness to candid feedback, she invited me to schedule regular check-ins with her.

These mentoring discussions were grounded in my documented five-year plan. With Hilda's direction, I developed a professional and personal growth plan that addressed financial, spiritual, professional, and community goals over a five-year horizon. Each session was used to review my goals, action plan, and progress. She did not hesitate to offer practical advice or to challenge me when I demonstrated indecisiveness.

Year after year, I saw the fulfillment of goals that Hilda and I talked through and game-planned. Her mentorship helped me understand my potential to lead in a front-line position. She then challenged me to grow and position myself for a larger role with more responsibility. The next step was an enterprise role with a strategic focus. It was

hard work and I had to earn every step of the journey; however, there were times it felt magical to look back and see the transformation of words on paper into reality.

Now, almost 15 years later, as the functional leader of a department with enterprise responsibility and strategic oversight, I can clearly see that Hilda pushed me on her shoulders so that I could see what was possible.

Dr. Saundra Wall Williams: My Relationship With Hilda Pinnix-Ragland

There are few people in your life who carry the role of friend, sister, counselor, and mentor—all at the same time! Hilda Pinnix-Ragland and I have that type of multifaceted relationship. She is a friend when I need a shoulder to lean on. She is a counselor when I need career advice. She is a mentor when I move to new, different, and higher levels in my life. She is a friend who has "been there and done that," and takes the time to nurture others.

I do not have a "blood" sister, yet I consider Hilda the sister who is there for me through the joyous and difficult times in my life. She has literally been a part of every aspect of my life for the past 30 years. In all the personal and professional relationships I have, none compares to my unique relationship with Hilda. Hilda Pinnix-Ragland is a remarkable woman who has helped many women across the world. I am fortunate to have experienced her compassion, patience, and encouragement.

Because of who she is, I am blessed.

Laquisha Parks: "Hilda Is My Career Magician!"

When I first joined Progress Energy, I was assigned a mentor. Her name was Hilda Pinnix-Ragland. I knew nothing of her, but she obviously knew me. We met in the parking lot of the Customer Service Center in Raleigh, North Carolina. The words she spoke to me that day forever changed my perspective on the importance of relationships, access, and feedback. She vowed to always give me honest feedback—and boy, did she!

When I worked for Hilda during her time as Northern Region Vice President, she delivered on her promise. My annual review was going well until I realized I had received the lowest rating possible in one of the five categories. I was devastated! I couldn't believe it. I felt so disappointed, and I didn't like her very much for those 50 minutes.

I was visibly mad because Hilda told me I wasn't doing my job. In hindsight, her feedback was a gift, because I would not have been promoted without her lessons on leadership development and improvement in my work style. I have since been promoted and done well, because Hilda has always had my back. Mentors who avoid giving direct feedback, especially that which is critical or negative, are doing a disservice.

I learned a valuable lesson that day. Sugar-coated conversations laced with phrases like, "Keep doing what you're doing," were debilitating and stunted my development and opportunities for advancement. That day I learned the value of mentorship. I learned that hard-core truth propels you to greatness. Hilda instilled the three P's in me through those hard conversations: patience, preparation, and perseverance. She taught me the value of perfecting my craft, which takes time, and being overly prepared and relentless in the face of opposition.

Hilda would tell me things that no other leader would. She cared enough to have the tough conversations; she was concerned enough to ensure that I didn't wallow in mediocrity, and she helped create paths

to success—paths that without her, I would have never been given the opportunity to follow.

Hilda is retired, but she still maintains a genuine interest in me, my career, and my success. She still orchestrates plays from the sidelines on my behalf and that is magical! She's more than a mentor. She is my career magician!

Retirement? No, "Re-*wire*-ment"—And Loving It

The third chapter of my life is now devoted to a career of "rewire-ment," which means self-selecting my priorities. The farm skills that I developed while feeding and herding cattle, and while picking beans, peas, apples, and an array of nuts, are now used to manage our pecan and blueberry farm. Pinnix Pecans, LLC is a work of love and compassion. My forefathers and mothers laid the foundation by planting the pecan seeds for trees many years ago. My sister, LaRosa, and I selected a low-maintenance farming crop. We wanted to dabble in other interesting challenges, such as my HPR STEM Academy for middle school minority girls, and to support "Closing the Achievement Gap," as well as Give a Kid a Smile or Backpack programs. Raising orchids of all varieties to enjoy at home or share with family and friends provides my mental therapy. I love gardening of all kinds, especially the herb garden. Growing spring and winter vegetables are fun to grow and wonderful to harvest and share.

Now in retirement, work today is for *me, myself, and I*. It fulfills my thirst for well-being, support, commitment, and contribution to society and my overwhelming desire to leave the world a better place for minorities and women. My life today is often filled on the speaking circuit on topics that include Women In Energy, leadership events, Path to Board Leadership, Leadership in general, and

Surviving in a Male Dominated Environment That Includes Work and Education, and more. In addition, corporate board work consumes at least a third of my time.

I love to travel. We take trips with our dear friends, Bill and Allyson. My sisters and I take an annual "Girls Trip." My husband and I love our annual anniversary trips. Spending time with our granddaughter, Kenley, is a top priority. Equally important is cooking and celebrating special occasions, holidays, and the annual Christmas brunch for family and friends.

Path To Board Leadership

Serving on boards that are for-profit and nonprofit help to strengthen and enhance my mental skills, while each endeavor keeps my life balanced and renewed with joy and happiness.

All major energy companies and most private and public companies have a board of directors. They make decisions that can impact its employees, your community, and the country. That's why it's important that membership on corporate boards be representative of a company's constituents. Boards of directors choose the CEO, Chair of the Board, and new board members, and they approve overall governance strategy. Boards make decisions about: executive compensation; whether to buy, sell, or merge with other companies; where corporate offices close and relocate; and how much priority a company gives to issues other than profits, such as social responsibility.

This is no different than the regulatory or political environment in which we do business. Gender diversity and minority representation are woeful. Several companies today have no women or people of color on their boards. While this sounds similar to corporate

America's C-suite, there is often a direct alignment, since most board members are current or prior C-suite executives. Corporate board work is an extension of an executive's transition to the next chapter after retirement. Plans are well underway for most males before they officially retire. Serving on a board requires time and commitment to learning industry trends such as artificial intelligence, disruptive technologies, cyber security, and more. The position carries risks and rewards and requires a person to do their due diligence and homework before entering an agreement.

Serving on a Corporate Board of Directors is similar, but not totally aligned to, the selection process of securing an advanced position of greater responsibility within a company. First and foremost, you must have the core required skills, namely: financial, audit, compensation, governance/nominating, and operational. Demonstrated senior strategic leadership and core competency are critical. For example, you would not want to sit on the audit committee without strong knowledge of auditing or financials.

Second, experience with intentional and strategic networking is important. There is an art to this skill. The real test of a relationship is this: when you call someone and leave a message, if you don't receive a return call or text within 24 hours, you do not have a strong, solid relationship. Relationships and networking require a lot of work and continued engagement.

Lastly, the board résumé and traditional résumé must be succinct and tailored to board competencies. It is different from your traditional bio/résumé/vitae. In addition, education within the Corporate Director clubs such as Women Corporate Directors, NACD, National Association of Corporate Directors, Alliance for Board Directors, Black Directors, and the Executive Leadership

Council are a must. The work inside the boardroom—and most importantly outside—will speak volumes about your continued nomination and your next board seat. Networks often work when you are not aware. Make sure your networks are working for you!!

Three Critical Elements To Joy And Happiness

While balancing overall equanimity to cultivate joy and happiness in my renewed life, we need to think of a triangle. At the center is Life Matters. The three elements are: Self-Preservation, Foundation, and Work.

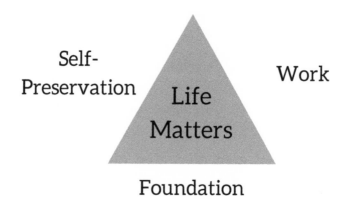

We then complete this triangle with our values. This helps us create our own vision. My triangle looks like this:

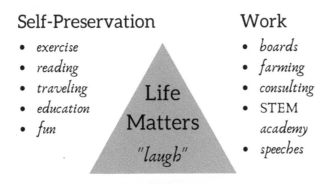

Self-Preservation

- *exercise*
- *reading*
- *traveling*
- *education*
- *fun*

Life Matters

"laugh"

Work

- *boards*
- *farming*
- *consulting*
- STEM *academy*
- *speeches*

Foundation

faith, friends, family, mentoring

Joy and happiness are then built on three lifelong skills that are highly recommended by all people, especially people of color and women, as you navigate the often turbulent waters of life. We often have the base competency while graduating from college, but question our abilities when confronted with the perils of Corporate America.

Three Lifelong Skills

1. COMPETENCE: continued ability to learn, develop, and grow

2. CONFIDENCE: belief in yourself and your abilities

3. COURAGE: to hold or fold

Key Questions To Contemplate While Reviewing Lifelong Skills

Ask yourself:

Where am I going?

What is my contribution?

What legacy will I leave?

Reflections of best practices for soon-to-be retired women or men include several years of planning and preparation. Your next 20 years require that you deliberately embrace several changes. After all, you have devoted almost 60 years responding to someone else's expectations.

As a child, I followed directions almost all of the time from my parents, grandparents, teachers, and elders. Performing in school and obeying the rules were expected, not negotiated, as I often tried to do. Even when I went to college at my beloved North Carolina A&T State University, high school performance was a given and so was college. Dr. Craig, the Dean, did not compromise if you were an Accounting major. Of course having my Uncle Charlie in the Engineering Department did not help my case for mediocrity. Uncle Charlie was relentless about education. While in line at my A&T graduation, Uncle Charlie came over to ask, "When are you going to graduate school?" In August, I enrolled at St. John's University for graduate studies. His words resonated throughout my life, even when I completed the Executive program at Harvard University's Kennedy School of Public Policy.

Both would say to me, "The company you keep makes or breaks you." Money provides you financial freedom when you make it work for you. In the long term, true trusted friends provide you guidance and a taste of reality. My life journey has afforded me

financial freedom while enjoying the things that are important for my legacy.

The last chapter of life must be filled with an abundance of love, laughter, joy, and happiness. Rewirement helps me to stop, focus, look, listen, and reflect. It is true; we all develop more wisdom as we increase in years.

Faithful Service

A closer walk with my faith and St. Ambrose Episcopal Church helps me enjoy and learn from my *purpose-driven* life, which includes serving with the St. Ambrose Altar Guild and as a Eucharistic Minister while taking communion to homes, hospitals, and assisted living facilities enhances my inner well-being. I am often asked to name my proudest moments other than childbirth, marriage, et cetera.

My answer remains, "Serving communion with ArchBishop Desmond Tutu at St. Ambrose." His sermon centered around the theme that love reigns as critical for today's tumultuous civil unrest.

My faithful service has provided many wonderful moments.

The first time I took communion to Dr. Joseph Banks, a retired priest from Virginia, I was a little nervous. He was a priest with a religious acumen much stronger than mine, and he taught school. After I drove to his daughter's house to administer communion, I sat in the car to pray that God would strengthen and guide me. Upon entering the home, Father Banks, his daughter, and granddaughter welcomed me with open arms. My being a female did not bother him at all. We enjoyed each other's presence until his death at age 96. I learned so much from him, about his life, and his love for his wife, daughter, and granddaughter. It was indeed a gift that keeps on giving. Father Banks' wisdom helped me understand the

death of my mom and lifelong friend, Sharon, who passed the year I decided to retire. Never put off what you should have done today!

Another moment occurred on visits to my principal, Mr. Harold Webb. He was instrumental in integration. Little did I know, he gave me records and photos of my entire career. It was indeed a full cycle of life when his family asked me to speak at his funeral. My title was, "A tribute from his favorite student to my favorite principal." He too is an A&T graduate.

Our life during and after the traditional work world becomes a key launching path for future engagements, mentoring, and self-preservation as it offers us a chance to give back, reflect, and lift high the banner of success for others to come. We were handed the torch, asked to keep the flame strong, and ignited. Today we must pass it to the next torchbearer.

Biography
Hilda Pinnix-Ragland

Hilda is a senior Fortune 500 business executive acknowledged for building best-in-class organizations that consistently achieve aggressive revenue and profit objectives. She is also a dedicated board member/advisor to numerous industry, educational, and community organizations, bringing new strategy and processes to enhance effectiveness.

Hilda brings a broad background in P&L management, strategic planning, economic development, communications, treasury & auditing, M&A integration, customer service, and operations. During her career, she has combined operating success—including leading a 600,000-customer energy delivery operation, achieving top financial, safety, customer service, and employee satisfaction results—with the ability to collaborate and build alignment with government, regulatory, and other stakeholders.

Most recently, Hilda served as Energy consultant for Duke Energy and Vice President, Corporate Public Affairs with Progress Energy and, following the merger, with Duke Energy. While at Progress, Hilda established the Corporate Public Affairs function, which was expanded to serve 31 states and international interests in Central and South America at Duke. In that capacity, she

collaborated with federal, state, and local officials and company leadership to develop responsible energy policy and advance the utility's international interests.

Hilda served in operating roles with Progress Energy, including Vice President, Northern Region, with management of distribution of electric service for more than 600,000 customers and community relations with a budget of $80 million, and as Vice President, Energy Delivery Services, leading environmental services, financials, transmission and distribution services, commercial, industrial and governmental account management, and support services. In both roles, she achieved top quartile performance in safety, customer satisfaction, and employee engagement.

Hilda has also demonstrated leadership in economic development, serving as Progress Energy's liaison with International Departments of Commerce to bring business to North Carolina, South Carolina, and Florida. In three years, she doubled Progress' annual revenue stream from new industries.

Hilda began her career on the financial side, serving as an accountant for Colgate Palmolive, a senior auditor for Arthur Andersen, and a financial analyst for Progress.

Hilda holds a Bachelor of Science in Accounting from North Carolina A&T State University and a Master of Business Administration from Duke University Fuqua School of Business. She also completed graduate studies in taxation from St. John's University and the Executive Program from Harvard University's Kennedy School of Government.

Hilda serves on the board of directors of RTI International as Chair of the Nominating and Governance Committee and Chair Audit Committee, Board of Advisors-8 Rivers Financial Capital, an

energy technology company and Chair of the Board for NC Dental Services, Inc., an insurance company for dentists. She currently serves on the NC A&T State University Board of Trustees and previously she served as National Chair of the American Association of Blacks in Energy, Board of Trustees of the College Foundation of North Carolina; was Co-Chair of the North Carolina Governor's transition team and State's Budget Reform and Accountability Commission; Presidentially nominated Board Member of the National Parks Foundation; State Board Member/Chair of the North Carolina Community College System; and Governor-appointed Treasurer for the NC Institute of Medicine. Hilda is a Chapter Fellow of the National Association of Corporate Directors and a Member of Women Corporate Directors. In 2018 she was recognized and selected as a Director to Watch by The Visionary Board.

Epilogue

With this book, we are issuing a call to action.

While we are celebrating the careers of five women in the energy industry, we can no longer afford the scarcity of African American women leaders and executives in the energy industry.

The US energy sector is experiencing significant growth and creating opportunities for investment and employment. Participation in this growth is vital for African American communities. The door must be open for: increased employment throughout the energy value chain; access to senior leadership positions; growth in African American-owned businesses; and increased representation on corporate boards.

With the sheer number of career opportunities projected over the next 30 years, this book is written as a call to action for deliberate and intentional efforts be made to increase the progression of women and minorities at all levels and in all sectors of the energy value chain. Corporations, educational institutions, and professional organizations must collaborate to ensure an equal playing field to demonstrate competency and to compete for career advancement; no handouts, just an equal playing field. To ensure readiness, we must invest our time and our money to support STEM education through all stages of academic and professional careers. We must also communicate that career opportunities in energy cover

a myriad of professional and blue-collar sectors. We must provide opportunities to increase the number of women and black-owned businesses in the energy sector. And lastly, we must all recognize the tangible benefit of visible role models and mentors to contribute to professional success.

While projections are uncertain due to policy impacts, the clean energy sector (renewable energy, energy efficiency, and advanced vehicle technology) job market in the United States is expected to grow significantly. Investments related to climate change, greenhouse gas emissions reductions, and renewable energy will help sustain clean energy job growth.

Regardless of income, consumers pay the same for each unit of electricity, the same price for each gallon of gasoline, and the same price for other energy products. This means that lower income consumers pay a significantly higher percentage of their gross income on energy consumption. Throughout our careers, each of us has fought to ensure that African Americans and other energy dependent communities have access to reliable, affordable energy. We call on corporations and energy professionals to join us in this pursuit.

Appendix

The American Association of Blacks in Energy (AABE) is a national association of energy professionals founded and dedicated to ensure the input of African Americans and other minorities into the discussions and developments of energy policies regulations, R&D technologies, and environmental issues.

Be Powered by AABE

STUDENTS

Looking at a career in the energy industry? Learn more about the AABE student chapters and what membership can mean for your future.

PROFESSIONALS

Not sure what membership in AABE will mean for you? Learn more about what membership in AABE can mean for your career.

MEMBERSHIP BENEFITS

Network with more than 1,900 of the best and brightest in the industry, from line supervisors to chief executives.

CONTACT INFORMATION

1625 K St. NW, Ste. 405
Washington, DC 20006
(202) 371-9530
info@aabe.org
www.aabe.org

Index